IMAGES
of America

St. Louis's
Delmar Loop

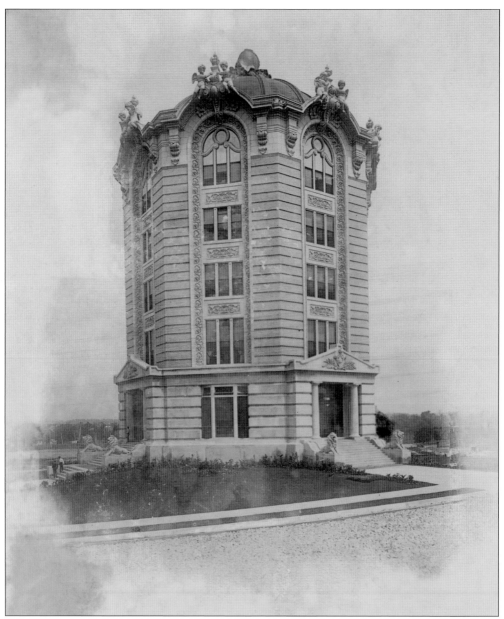

WOMAN'S MAGAZINE BUILDING, 1904. If magazine publisher Edward Gardner Lewis wanted the world to know he had arrived, the headquarters building he commissioned fit the bill. Octagonal, 135 feet tall, with two-ton cupids decorating its roofline, the building houses a massive, still-operative 80-inch searchlight in its dome. It also features an Italian marble spiral stairway and eight murals on the lobby ceiling depicting stages of Lewis's life. The building, University City's city hall since 1930, was completely renovated in 2008, funded by a $2.9-million bond issue, and was certified LEED. (Courtesy of the archives of the University City Public Library.)

ON THE COVER: DELMAR LOOP SHOPPERS, 1950. A special treat for kids of all ages was a trip to the vast wonderland of the five-and-ten, which might include some ice cream at the soda fountain. (Courtesy of the archives of the University City Public Library.)

IMAGES
of America

ST. LOUIS'S
DELMAR LOOP

M.M. Costantin
Foreword by Joe Edwards

ARCADIA
PUBLISHING

Published by Arcadia Publishing
Charleston, South Carolina

Printed in the United States of America

Library of Congress Control Number: 2012949080

For all general information, please contact Arcadia Publishing:
Telephone 843-853-2070
Fax 843-853-0044
E-mail sales@arcadiapublishing.com
For customer service and orders:
Toll-Free 1-888-313-2665

Visit us on the Internet at www.arcadiapublishing.com

For Carrie and Jim, who grew up in the Loop

CONTENTS

FOREWORD

During the past 40 years, the Delmar Loop has evolved into one of the most vibrant and entertaining areas in the United States. In 2007, the American Planning Association designated the Loop "One of the 10 Great Streets in America." However, like many streets in cities across the country, Delmar has had its ups and downs.

In the early 1900s, the first buildings in the 6000–6600 blocks of Delmar Boulevard were constructed along a streetcar route from downtown St. Louis that made a "loop" and headed back downtown or to other areas. By the 1920s and 1930s, the Loop, near Washington University, was an established high-fashion shopping district surrounded by fine residential neighborhoods.

In the 1940s and 1950s, as postwar prosperity came to the middle class and more families could afford an automobile (and in some cases two!), the first suburban shopping malls were constructed and some top-tier stores moved out of the Loop. In the 1960s, stores continued to move away, as did many residents, and the area was in a steep decline.

The gradual turnaround of the Loop began in the early 1970s, with municipal legislation that limited occupancy of first-floor storefronts to retail shops, galleries, and restaurants in order to attract more pedestrians. Nationally renowned restaurant and music club Blueberry Hill was the first in a new wave of owner-operated businesses.

The sidewalks along Delmar were widened to encourage foot traffic and outdoor cafés. In the 1980s, dusk-to-dawn lights, trash receptacles, and flower planters were added to make the Loop brighter, cleaner, and more colorful.

The nonprofit St. Louis Walk of Fame was founded in 1988 and became a unifying attraction for the area. Now, more than 130 stars and informative plaques are embedded in the sidewalks.

In the 1990s, the Delmar Loop MetroLink station opened. Visitors can ride a clean, quick light-rail train right to the Loop and begin their visit by walking west. In 1995, the elegant Tivoli Movie Theatre was beautifully restored. This, along with many new gift shops and clothing boutiques, signaled that the Loop had arrived.

Expansion into the City of St. Louis started in 2000, with the grand opening of The Pageant, a concert nightclub with more than 2,000 seats that has featured artists such as Bob Dylan, The Roots, Green Day, Dolly Parton, and Foo Fighters. Many consider the Loop to be the live music center of St. Louis, with 10 stages that feature music of all genres. Soon after, the Pin-Up Bowl bowling alley and martini lounge opened.

Exciting new attractions include the boutique Moonrise Hotel and the Eclipse Restaurant; the Delmar Loop Planet Walk, where one can take a three-billion-mile stroll from the sun to Neptune on a 2,880-foot scale model of the solar system; the new Chuck Berry statue, an eight-foot bronze likeness dedicated to the "Father of Rock 'n' roll"; and the Centennial Greenway bicycle and pedestrian trail. In spring 2014, a new fixed-track trolley will connect the Loop with two MetroLink stations and Forest Park attractions.

Explore the Loop's collection of specialty shops, clothing boutiques, and galleries. Dine at one of the award-winning, multinational restaurants. Immerse yourself in the rich social, ethnic, and cultural diversity of this historic district. Welcome to the Delmar Loop!

—Joe Edwards

ACKNOWLEDGMENTS

I would like to thank the following persons and institutions for their assistance in the completion of this book: the Historical Society of University City, including president Eleanor Mullin and archivist Susan Rehkopf; the University City Public Library, including director Patrick Wall, Christa Van Herreweghe, David Bowser, and Sally Master; Jaime Bourassa, associate archivist, Missouri History Museum Library and Research Center; former University City mayors Janet Majerus and Joe Adams; former city council member Elsie Beck Glickert; former city manager Charles T. Henry; Brad Hines, Hope Edwards, Debbe Franke, and Mark S. Gilliland; Paul and Suzanne Schoomer; Audrey Mathews; Bob and Barb Suberi; Cheryl Adelstein, the Washington University Director of Community Relations and Local Government Affairs; champion Loop chroniclers Esley Hamilton, Nini Harris, Ilene Kanfer Murray and the late C. Edwin Murray, Judy Little, David Linzee, Jim Longo, Mary Henderson Gass, and John Wright; and Joe Edwards, without whom . . .

INTRODUCTION

The Delmar Loop existed years before magazine publisher and tireless entrepreneur Edward Gardner Lewis came on the scene. Day-trippers from St. Louis City trolleyed along Delmar Boulevard to the Delmar Garden Amusement Park, the Delmar Race Track, or other places of amusement that had grown up around the loop that the trolley made through the southwest corner of the amusement park on its way back downtown.

But University City founder E.G. Lewis never met an opportunity he did not like. The Connecticut-born Lewis had arrived in St. Louis at the turn of the 20th century with a suitcase full of nostrums and a head full of ambitions. Handsome, well-spoken, the son and grandson of Episcopal ministers, and a college man if not a college graduate, Lewis quickly gained traction in the community, especially, it appears, among bank loan officers and, later, investors.

In 1901, he bought the *Winner*, an advertisement-heavy magazine. Noting the success of the *Ladies Home Journal* and similar publications, Lewis renamed his publication the *Woman's Magazine*. He recognized the vast market of readers opening up as women, including his wife, Mabel, began to organize and vigorously campaign for women's suffrage. Lewis himself might be described as a sympathetic but shrewd suffragist. Advertisers, he predicted, would flock to a magazine targeting this substantial new audience. And, after all, advertising was a publisher's bread and butter, the reason for magazines in the first place. With the implementation of the Rural Free Delivery system, mailing magazines cheaply to newly available subscribers was good business. Lewis decided he wanted to build a publishing empire and make a fortune.

Success came as he had predicted. Twice his magazine and printing presses outgrew his headquarters in downtown St. Louis. So, like many ambitious Americans before him, he headed due west. In this case, however, he relocated only a mile beyond the city limits, in a largely undeveloped section of St. Louis County. In 1876, City of St. Louis voters had approved separation from St Louis County and the establishment of a home rule charter, the first in the nation. By 1900, St. Louis was the fourth largest city in the nation, and real estate development in its central corridor was nearing the city's western border. Lewis had kept an eye on this progression and found it to be attractive. He would go west and buy land while it was still cheap and offered abundant choices.

He also wanted to build high on a hill so that his publishing complex would become a conspicuous landmark. He found his hill on Delmar Boulevard, overlooking the trolley loop and conveniently located within walking distance of the construction sites of the 1904 Louisiana Purchase Exposition and Washington University's brand-new campus.

In 1902, he purchased 85 acres, enough land to contain his magazine publishing complex and what he envisioned as the beginning of a series of planned neighborhoods along Delmar Boulevard. Lewis hoped that these residential developments would avoid the fate of many beautiful St. Louis neighborhoods that had been overtaken by industry and disorder. He also envisioned starting a women's league associated with the *Woman's Magazine* and another of his publications, the *Farm Woman's Journal*. Such an organization might evolve into a sort of people's university offering correspondence courses in many topics. As the idea of women's suffrage took hold, the women of still largely rural America were hungry for education, as were their urban sisters.

In September 1903, work began on the Lewis Publishing Company's headquarters building, designed by architect Herbert C. Chivers. One can only imagine the conversations between the

two men that resulted in the birth of a wondrous 137-foot-tall octagonal building with a powerful searchlight inside its domed copper roof and two-ton clusters of terra cotta cupids decorating its roofline. Even more fantastic is the fact that the building was finished in time for the opening of the World's Fair on April 30, 1904. Its searchlight's beam touched the facade of Cass Gilbert's Palace of Fine Arts across Forest Park.

Lewis had already built the first house in University Heights No. 1, the first of his planned neighborhoods. The home was a substantial 15-room Tudor structure situated on what he described as the least desirable plot in the subdivision, one that contained a marsh. Lewis wanted to demonstrate what could be done with what might be considered an unsuitable plot for a house. The Lewis's property was transformed with gardens and an orchard and vineyard, and the marsh became a large boating pond complete with resident ducks. Perhaps the most interesting part of Lewis's plan for University Heights No. 1 was that it should contain houses that a variety of incomes could afford, with the big houses of the wealthy built at the top of the hill along Delmar and houses gently decreasing in size and cost as the plats descended the hill. In addition, the streets in the subdivision were gently curving, instead of set on a grid.

Real estate was not Lewis's only interest in addition to his thriving publishing company; he wanted to start a bank. But not just any bank. He wanted to start a bank-by-mail system that would serve his many subscribers who lived in small towns or on farms, far from the nearest lending institution. His bank would provide a place for safekeeping of their funds and valuables, and they would be able to write checks on their accounts to pay bills. Checking accounts were in short supply in the nation's banks, because, at the time, there was no national clearinghouse for checks, which meant a bank would cash checks only drawn on a bank in its same city. Lewis had been able to make arrangements with major banks in New York, Chicago, New Orleans, Seattle, and San Francisco: they would honor checks drawn on People's United.

The US postmaster general called Lewis's system a swindle and had all mail addressed to the bank returned to its senders with the envelopes stamped "Fraudulent." The bank went into receivership. Some suspected that the post office feared People's United becoming a strong and direct competitor with its own quite small postal savings system. At the same time, the postmaster general attempted, unsuccessfully, to revoke the cheap second-class mailing privileges used to send out Lewis's publications. Lewis was mailing 1.5 million copies of the *Woman's Magazine* each edition, plus 500,000 copies of the *Woman's Farm Journal*.

Lewis had already employed Herbert Chivers to design an imposing building for the new bank, right across Delmar from his octagonal marvel. This time, Chivers used a stark Egyptian style and had the building sheathed in white marble. It was already under construction when the post office put the bank out of business. Undaunted, Lewis rechristened the building and its purpose. It became the headquarters of a new enterprise, the *Woman's National Daily*, and Chivers reconstructed its interior to harbor newspaper offices, huge printing presses, and almost equally large folding machines.

The Missouri attorney general had become interested in the fact that the same people who had been officers of the erstwhile bank were also officers of the Lewis Publishing Company and the University Heights Realty & Development Company, as well as of other, lesser Lewis enterprises. It was true that Lewis certainly appeared from time to time to "borrow" funds from one enterprise to finance another, but the postmaster general's continuing interest in Lewis appears to have trumped that of a mere state attorney general.

In 1907, Lewis's fortunes suffered what was very nearly a fatal blow at the hands of the postmaster general; his second-class mailing privileges were successfully revoked on the grounds that his magazines were not magazines at all but actually advertising circulars. Lewis was eventually cleared of all charges, but the process had taken more than a year, and in that time, none of his publications could be mailed. His subscription list was hopelessly out of date, and he had no money. But E.G. Lewis had a plan.

Once again, it involved women and magazines but much more than that. He founded the American Woman's League (AWL), an organization based in the Lewis Publishing Company

that promised its members, among other things, a People's University that offered correspondence courses in a myriad of subjects, and chapter houses, built and furnished by the AWL, on land donated by the chapter. To become an AWL member, one had to either pay $52 in cash or sell $52 worth of Lewis publications and affiliated publications. The response to the AWL was immediate and impressive; according to Lewis, 700 chapters quickly formed in many parts of the country.

Lewis erected another building, this time the Art Academy, the initial building on what was planned to be the future campus of the People's University in University City. Somehow, he managed to persuade some of the most gifted and influential potters and ceramists from Europe and the United States to join the Art Academy faculty. A few months later, in June 1910, the AWL held its first, and only, convention, in University City. While a good time was had by some, it was not had by all. Some AWL members went home to their chapters, discussed their concern about AWL finances, and elected state regents to meet with Lewis the following January. It was not a good situation, but, as ever, Lewis had a plan.

Since women's suffrage was nearing actuality, Lewis suggested that women would be well served to become part of the American Woman's Republic, an organization modeled on the US government and designed to prepare women for the roles they would assume in government. Mabel Lewis was elected its first president. The capitol of the American Woman's Republic would be based in University City. Lewis had prepared a scale model of what the capitol plaza would look like. It is on display in the lobby of University City's city hall, the former Magazine Building.

Many of Lewis's ideas became reality, but in the end, his decidedly laissez-faire handling of financial matters created problems for him and for his ambitions. In 1913, he left University City, the model St. Louis suburb he had founded and led as mayor for three terms, to create a utopian colony in Atascadero, California, for the American Woman's Republic. Having led a busy life full of ideas, buildings, and some misadventures, he died there in 1950 at the age of 81.

The University City mayors who followed Lewis in office concerned themselves with the growth of their city by implementing the school district, paving roads, installing a citywide sewer system, setting aside land for a planned park system, and lighting the streets. Throughout the 1920s, 1930s, 1940s, and even into the 1950s, the Delmar Loop prospered, offering fine restaurants, the leading shops, and a gorgeous movie theater, not only to town folk, but to the thousands of people each workday that commuted by streetcar through the Loop.

The 1960s and the decades that followed were hard on cities in general, and on the Loop in particular. Buses replaced streetcars, but most commuters had started driving their own cars to work from the suburbs where they lived, shopped, went to school, and went to the movies—at the brand-new megaplexes. In the Loop, storefronts became offices, remained vacant, or sometimes were just boarded up. As early as 1959, the city government began to assess the problems in University City's East End of dilapidated apartment buildings, and a former streetcar right-of way, now weedy, overgrown, and full of abandoned junk. The government did not neglect the Loop; in the 1970s, young people began to take a chance on doing business in the Delmar Loop.

Chief among them is Joe Edwards, who is selflessly dedicated to a Delmar Loop he first knew as a co-owner with his wife, Linda, of a hole-in-the-wall pub called Blueberry Hill, at a time when the Loop had become shabby and forbidding. If E.G. Lewis was someone who never met an opportunity he did not like, Joe appears to be that rare soul whose keen insight into the problems of urban neighborhoods results not only in possible and viable solutions to these problems, but also leads to the positive action he has taken so often.

Today's lively and fascinating Delmar Loop, and its rise from near collapse, has become a textbook for neighborhoods all over the nation that wish to regain their former vigor and good health. It is rather doubtful that E.G. Lewis ever conducted business in anything but a three-piece suit, but the odds are very good he would recognize as a brother-in-plans the man with the pony tail, brightly patterned shirts, and head full of amazing ideas.

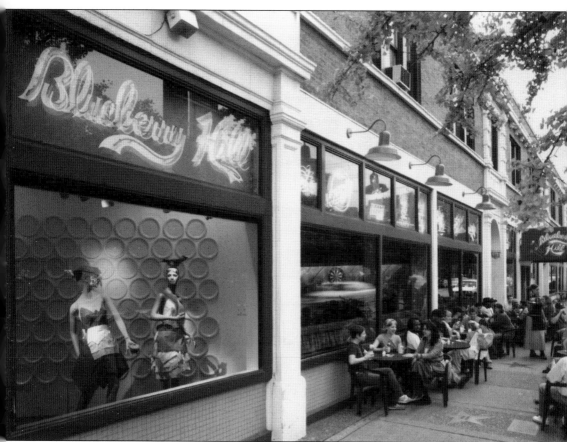

BLUEBERRY HILL. University City narrowed Delmar and widened the sidewalks in the Loop in order to attract cafés like this one at Blueberry Hill. The gentleman with the ponytail at lower right is Joe Edwards.

One

THE GATES
OF OPPORTUNITY

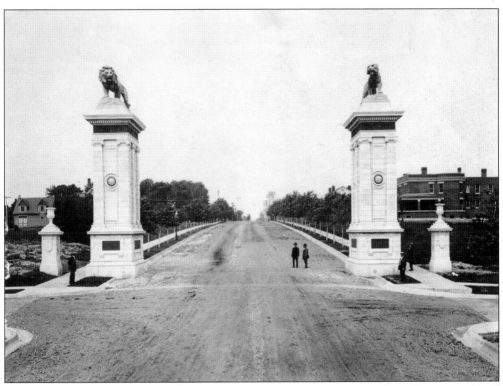

LION GATES, 1911. In 1909, in another of his inspired moments, Edward Gardner Lewis hired architects Eames and Young to design imposing entry gates for University Heights, the series of seven subdivisions Lewis envisioned being built along Delmar Boulevard west of the Loop. George Julian Zolnay, director of the Art Academy of Lewis's People's University, created the lion sculptures (one of which was actually a tiger). Lewis sometimes referred to the giant structure as "The Gates of Opportunity," since, by 1911, Delmar was a broad avenue extending just over one mile from the Delmar Loop to Hanley Road, the western limit of University City. Dr. Pickney French's house in the University Heights No. 1 subdivision is on the right. For Lewis, the future was always straight ahead. (Archives of the University City Public Library.)

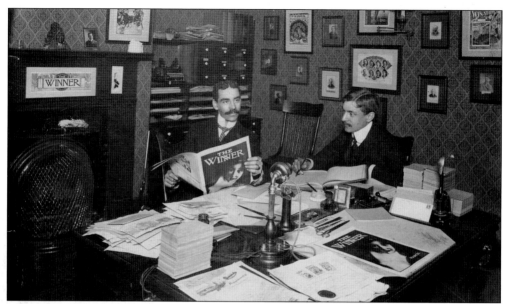

OFFICES OF *THE* WINNER, 1901. E.G. Lewis (right) and his associate, Howard Nichols, are seated in the offices of the Mail Order Publishing Company in downtown St. Louis. Lewis bought the *Winner* magazine in 1901 and, the following year, retitled it the *Woman's Magazine*. Magazine publishing had become a particularly lucrative business; the implementation of Rural Free Delivery service in 1896 had opened a vast new pool of subscribers. Subscriptions typically cost 10¢ a year, advertising $6 a line. (Archives of the University City Public Library.)

DELMAR LOOP, LOOKING EAST, 1903. Lewis had calculated (correctly) that St. Louis's population would continue to move west. In 1902, he purchased 85 acres of land on Delmar Boulevard one mile west of the St. Louis city limits, overlooking the popular Delmar Garden amusement park. The area was largely undeveloped except for the park and, further east, the Delmar Race Track. The large white building on the left is part of the amusement park. To its right, a curved row of power poles marks the loop of track on which the No. 10 Delmar trolley turned back toward downtown. (Archives of the University City Public Library.)

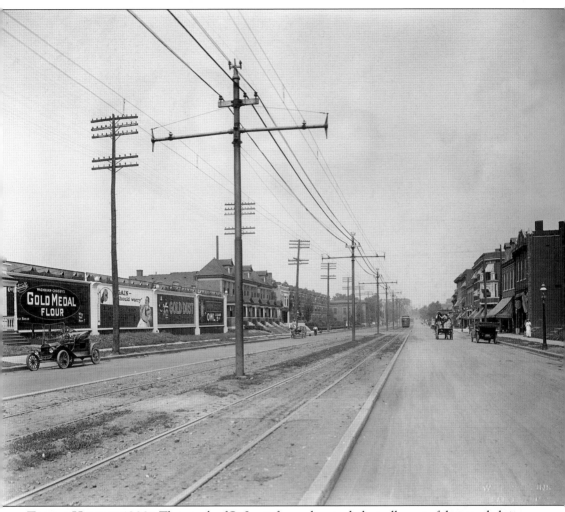

Trolley Holiday, 1900s. Thousands of St. Louis fun-seekers took the trolley out of the crowded city to the amusement parks that enterprising promoters had built at the end of trolley lines or at trolley transfer points. Riders on the No. 10 Delmar streetcar wanting to go further into the hinterlands could transfer to the Creve Coeur line in the Delmar Loop. (Missouri History Museum.)

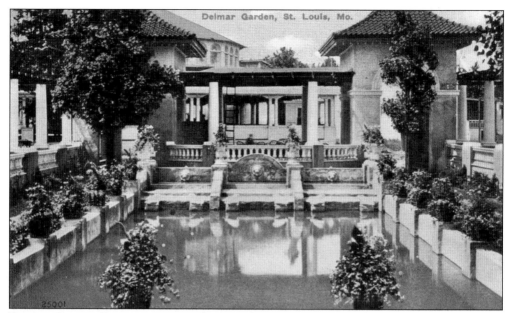

DELMAR GARDEN PAVILION, 1901. Delmar Garden's cornucopia of attractions included a midway and rides, its own movie house, and a "Strictly modern Opera Stage enclosed by a pavilion" seating 4,000, where famous stars of the era entertained. The park advertised itself as "Forty acres of magnificent ground, replete with the latest Amusement Devices at an outlay of over one hundred and twenty-five thousand dollars." It also offered city-weary visitors the tranquility of its pavilion pool, pictured here. (Archives of the University City Public Library.)

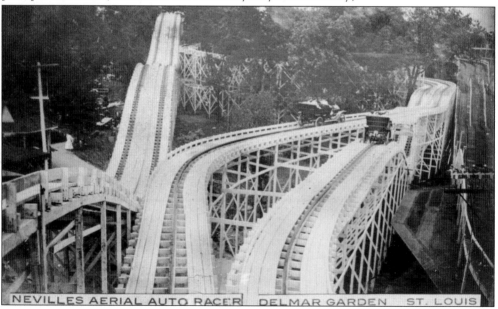

DELMAR GARDEN AERIAL RACERS, 1905–1910. Not for the faint-hearted were some of the amusement park's rides. This one ran through the southeastern corner of the park on an elevated track. Delmar Garden had at least three roller coasters and a steeplechase ride "that annually carries three hundred thousand lovers of spirited and wholesome sport." (Archives of the University City Public Library.)

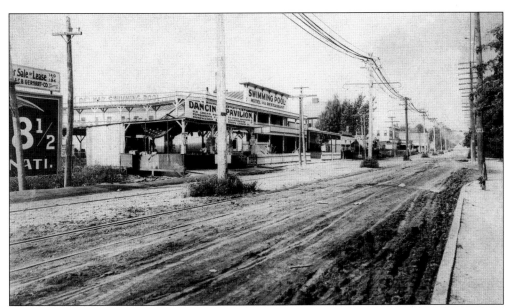

DELMAR INDOOR SWIMMING POOL, 1910. Located on the south side of the 6600 block of Delmar Boulevard across the unpaved street from the amusement park and racetrack, the Delmar Swimming Pool had its own hotel, restaurant, and dancing pavilion. It offered "gauffrettes," waffle-fried potatoes, on one of its banners, and one could order a Celery Cola to go along with the fries. (Missouri History Museum.)

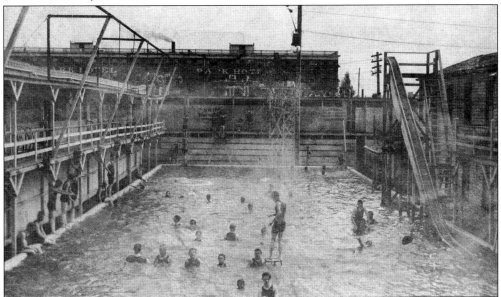

DELMAR OUTDOOR SWIMMING POOL, 1905–1908. For plein air swimmers, there was an outdoor pool at the corner of Delmar Boulevard and Melville Avenue. A 1904 World's Fair building, the Park Hotel, now a desirable residential hotel, looms in the background. In 1914, it became the Christian Old Folks Home. In 1977, the building was completely renovated and renamed the Greenway Apartments. It was one of the first major adaptive reuses of a building in the Loop. Today, it is owned by Washington University and serves as off-campus housing. (Archives of the University City Public Library.)

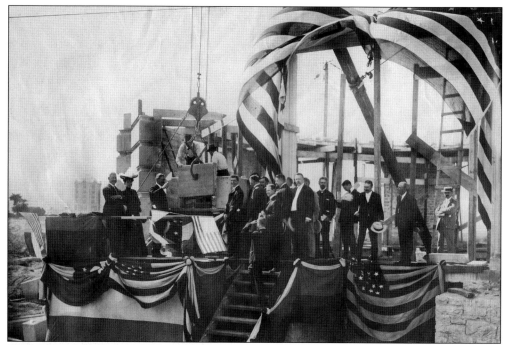

Cornerstone Ceremony, 1903. On August 29, 1903, David R. Francis, former governor of Missouri and president of the Louisiana Purchase Exposition, laid the cornerstone for the new Lewis Publishing Company headquarters on Delmar. The participation of such a luminary in the cornerstone ceremony was a publicity coup for Lewis. (Archives of the University City Public Library.)

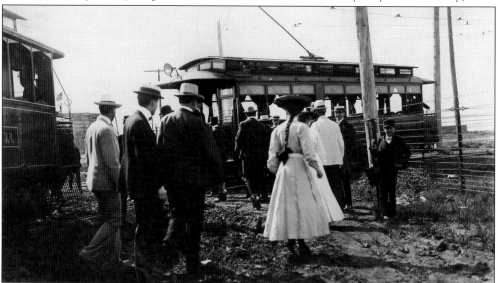

Taking the Trolley Home, 1903. After the laying of the cornerstone, Lewis Company employees head for the Delmar Loop to catch a trolley home. The advent of fast, efficient, affordable electric trolley service had a tremendous impact on city dwellers. Previously, folks had to find work near their home because the horse-drawn trolleys were too slow and private transportation too expensive to travel any distance at all. Now, with a transfer ticket in hand, they could comfortably commute long distances between home and work. (Archives of the University City Public Library.)

LEWIS PUBLISHING COMPANY BUILDING, 1903–1904. Lewis wanted the building and his huge Press Annex up and running by the April 1904 opening of the World's Fair. Construction started in earnest at the beginning of September 1903. This photograph, taken in the winter of 1903–1904, shows the pace at which the builders worked. The exterior walls are complete and framing is in place for the domed roof. (Archives of the University City Public Library.)

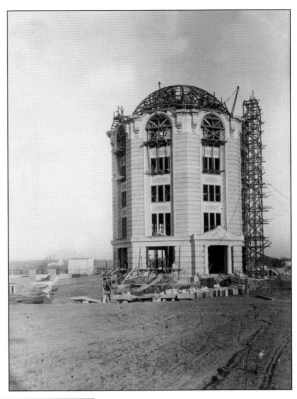

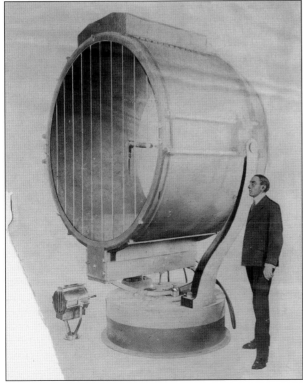

SEARCHLIGHT SURPRISE, 1904. Lewis's ace in the dome was an amazing searchlight, one that he knew would draw 1904 fair visitors to his offerings of magazine subscriptions, housing plats, and bank-by-mail services. General Electric filled his order for an 80-inch carbon arc light weighing eight tons. The illustration shows the light flanked by a standard-sized searchlight and a five-foot-eight-inch-tall person. YouTube offers at least two videos depicting the history and current operation of the light. (Archives of the University City Public Library.)

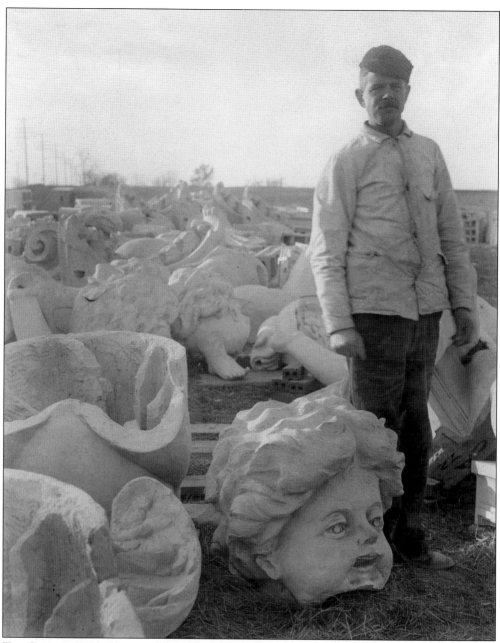

THE CUPIDS, 1904. The searchlight in the dome was not the only touch that Lewis planned for the top of his new building. Two-ton clusters of terra-cotta cupids, created by sculptor William Bailey (who may or may not be the bemused gentleman in the photograph), were installed on the building's roofline. Years later, they were removed when it was decided that the cupids had become a safety hazard. (Archives of the University City Public Library.)

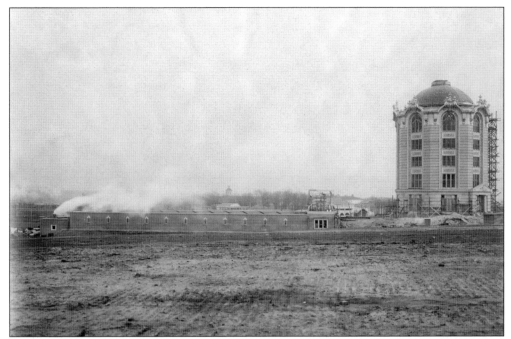

LEWIS PUBLISHING COMPANY BUILDING, EARLY 1904. The two-ton cupids are in place, the copper roof has been installed, and Bailey's lions guard the entrances. The massive Press Annex on the north side of the tower is complete except for its stunning glass-enclosed conservatory entrance, still under construction (right center). (Archives of the University City Public Library.)

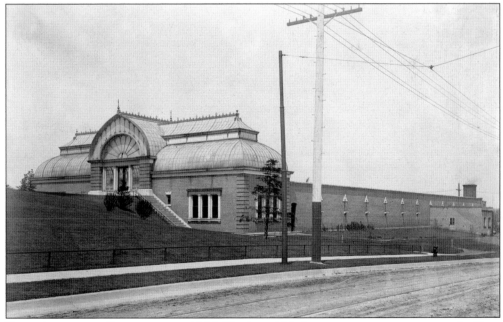

PRESS ANNEX AND CONSERVATORY, 1904. The beautiful glass conservatory entrance to the Press Annex, which also contained a balcony that allowed visitors a view of the busy pressroom below, was eliminated in 1908 when the annex, already short of space, was remodeled and a second-story was added to the building. (Archives of the University City Public Library.)

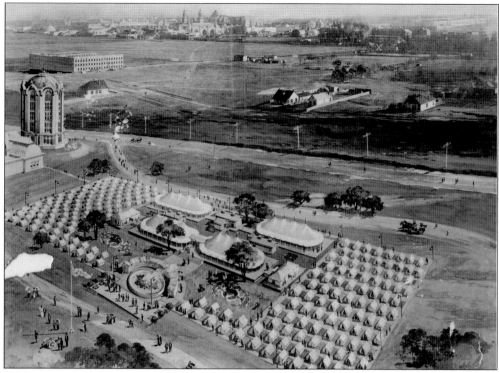

WELCOME TO CAMP LEWIS, 1904. Lewis established a tent city on property adjacent to the Magazine Building to provide his subscribers and other visitors to the Fair with comfortable, affordable accommodations. For 50¢ a night per person, campers stayed in tent-cabins with wooden floors, electric lights, and iron beds with mattresses. Public showers and baths, recreational equipment, and smoking areas were provided nearby. (Archives of the University City Public Library.)

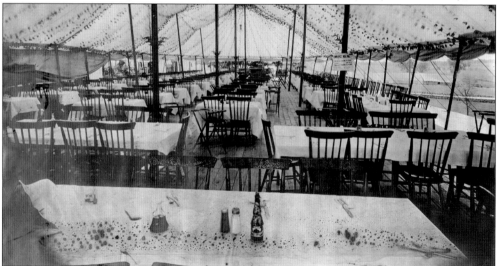

CAMP LEWIS DINING TENT, 1904. Camp Lewis had two large dining tents. Lewis hired Chicago caterer John Thompson to provide meals for camp guests. Lunch (25¢) and dinner (50¢) could be purchased in the camp commissary. This tent is decorated with strands of ivy. (Archives of the University City Public Library.)

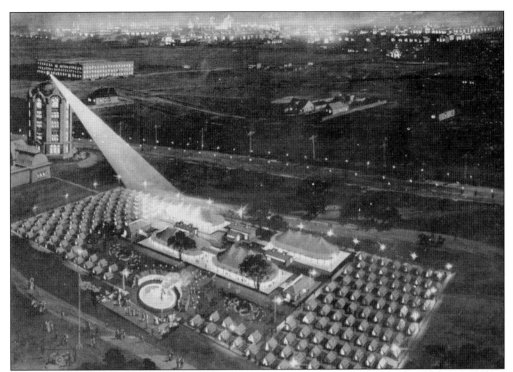

CAMP LEWIS AT NIGHT, 1904. Lewis kept a family atmosphere at the camp. No intoxicants were allowed, and there were nightly bonfires and musical entertainment. In the distance are the dazzling electric light displays of the Fair. The beam of the Magazine Building's gigantic searchlight is entirely capable of lighting up the facade of Cass Gilbert's Palace of Fine Art (today's St. Louis Art Museum) miles away at the fair. (Archives of the University City Public Library.)

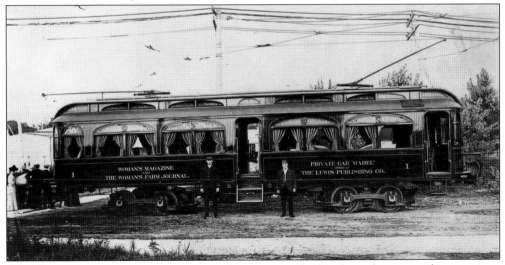

A STREETCAR NAMED MABEL, 1904. Named for Lewis's wife, this elegantly appointed streetcar was built by the St. Louis Car Company and was on display at the St. Louis World's Fair. Its interior was painted green with yellow upholstery, and it was decorated with inlaid woods. It was another means by which Lewis kept the company name in front of fair visitors (and potential subscribers) from all over the country. (Archives of the University City Public Library.)

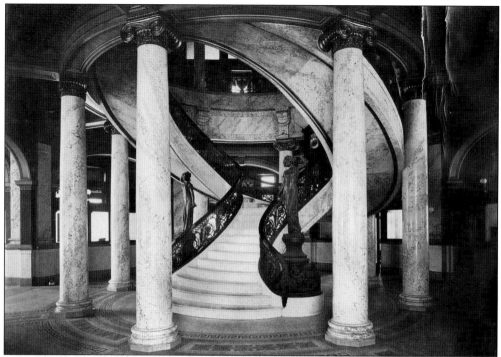

LEWIS PUBLISHING COMPANY LOBBY, 1904. Lewis's office tower soon became familiarly known as the Magazine Building. Its beautiful public entry was yet another tourist favorite. William Bailey, of the two-ton cupids, sculpted the graceful maidens at the base of the staircase. (Archives of the University City Public Library.)

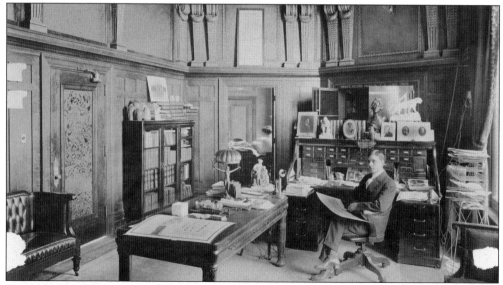

OFFICE OF E.G. LEWIS, 1904. While World's Fair tourists flocked to see the wonders of the Lewis Publishing Company complex, Lewis himself was hard at work. He sought perfection not just for every project he envisioned and executed but also for himself. His office in the Magazine Building had quarter-sawn oak wainscoting, decorative plasterwork, and, out of sight, his own private vault. (Archives of the University City Public Library.)

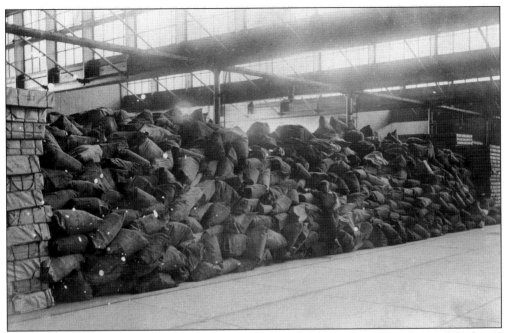

MAIL BAGS, 1906. A worker (right of center) leans against the staggering volume of the Lewis Publishing Company's daily outgoing mail. The *Woman's Magazine* mailed 1.5 million copies each issue, and the *Woman's Farm Journal*, 500,000 copies. (Courtesy of the University City Public Library Archives.)

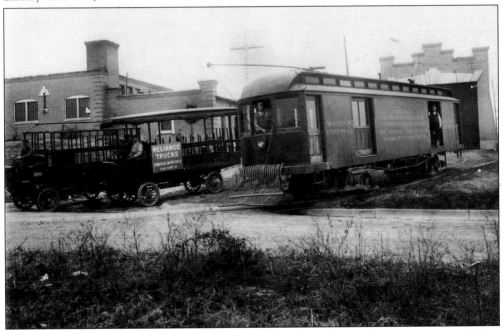

OUTGOING MAIL, 1906. Lewis Publishing used both trucks and streetcars to transport mail from the printing plant to the railroad station. Streetcar tracks ran from Delmar Boulevard to the back of the Press Annex to facilitate loading. Lewis posted circulation figures for his major publications on the sides of the streetcars. (Courtesy of the University City Public Library Archives.)

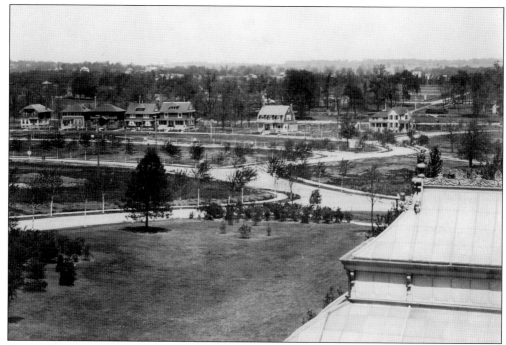

MODEL NEIGHBORHOODS, 1908. Lewis (and other investors) owned the University Heights Realty and Development Company. He planned a series of seven "City Beautiful" subdivisions going west along Delmar, each designed so that it was protected from haphazard growth. Harvard Avenue is the first street in the foreground, followed by Cornell Avenue and then Columbia Avenue. The houses are all located on Amherst Avenue. (Archives of the University City Public Library.)

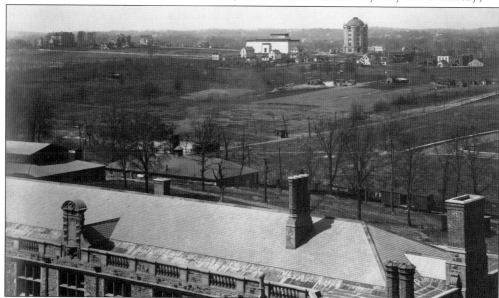

VIEW OF THE DELMAR LOOP FROM WASHINGTON UNIVERSITY, 1907. The proximity of an established university meant two things to Lewis: stability of the area neighborhoods, and potential homebuyers. What could be better than university faculty moving into the houses his company was building in the University Heights No. 1 subdivision? (Archives of the University City Public Library.)

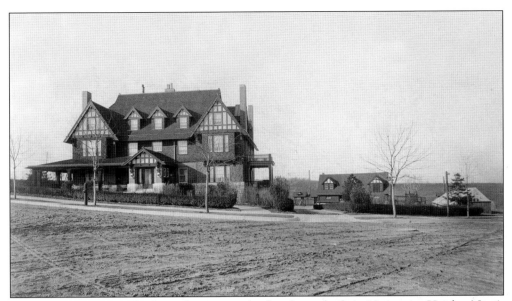

LEWIS HOUSE, 1904. The Lewis house was the first home built in University Heights No. 1. When the subdivision was being laid out, Lewis reportedly purchased the least desirable piece of property in order to show how tastefully even a problem plat could be developed. He and his wife built this 15-room, Tudor-style house at 2 Yale Avenue. (Archives of the University City Public Library.)

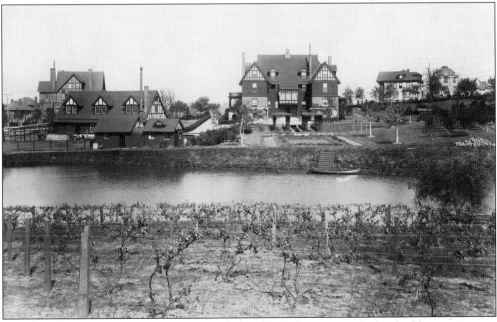

LEWIS HOUSE AND POND, 1906–1909. Mabel and E.G. Lewis turned what had been a swampy bottom into an attractive pond and garden, with their stables and a pergola nearby. When a vein of exceptionally fine clay was found on the property, the Lewises became keen potters and converted what had been two chicken houses into a pottery studio. The long-vacant Lewis house burned down in the 1940s, but the pond remains as the centerpiece of University City's Lewis Park. (Archives of the University City Public Library.)

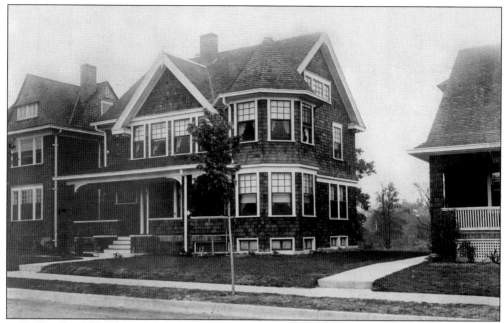

6955 AMHERST AVENUE, 1906–1907. Other sections of the University Heights No. 1 subdivision began to be built up. This house was one of a group of residences built on speculation by the University Heights Realty & Development Corporation. (Archives of the University City Public Library.)

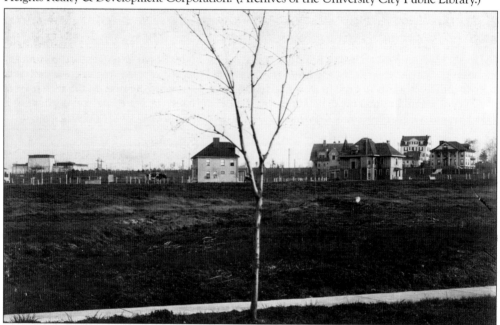

COWS ON CORNELL, 1907. This photograph was taken in University Heights No. 1, looking southeast toward the Delmar Loop. The house at the top of the hill, second from right, is 6965 Delmar, and the house with the columns (right) is 6970 Princeton. The houses in the foreground are on Cornell Avenue, where one householder is keeping cows, not an uncommon practice at the time. In stark contrast stands the Woman's National Daily Building (far left). (Archives of the University of City Library.)

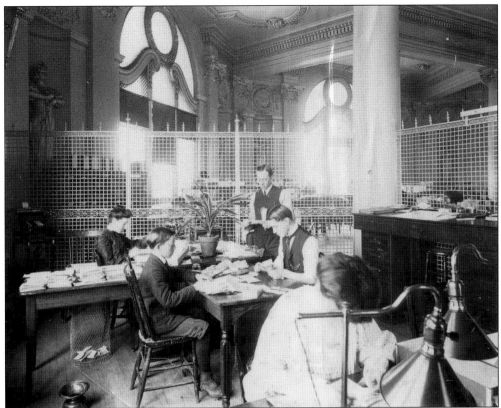

PEOPLE'S UNITED STATES BANK, 1905. When Lewis announced his latest venture, a bank-by-mail service for his subscribers called the People's United States Bank, the response was swift and overwhelming. It was now time to move the bank out of its crowded quarters on the fifth floor of the Magazine Building and into a building of its own. Here, bank employees are working in what is now University City's city council chambers. (Archives of the University City Public Library.)

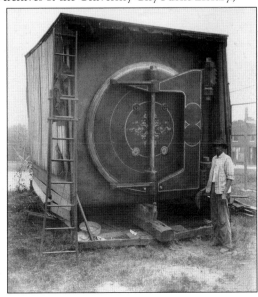

BANK VAULT, 1905. The first thing Lewis did after putting Henry C. Chivers, the Magazine Building's architect, on the job designing the bank was to buy the biggest vault he could find for his burgeoning bank. This safe, manufactured by the Manganese Steel Safe Company, won first prize at the 1904 World's Fair. The safe was never installed, but it remained on the Lewis Publishing Company premises until 1912. (Archives of the University City Public Library.)

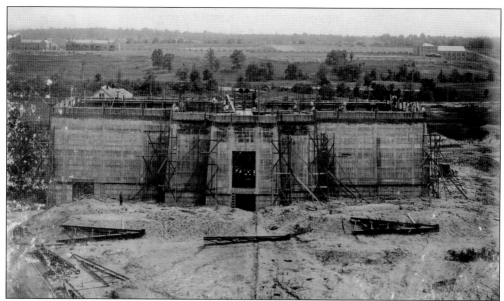

People's United States Bank Building, 1905. Lewis chose a site directly across Delmar Boulevard from the Magazine Building for his new bank and told Chivers he wanted an imposing structure. Chivers chose an Egyptian style popular at the time, complete with an interior decorated in Egyptian themes. The exterior would be sheathed in white Georgian marble with a copper cornice. (Archives of the University City Public Library.)

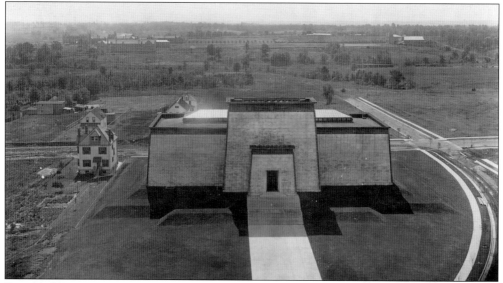

People's United States Bank Shuttered, 1905. The Missouri attorney general was not interested in white marble; he was interested in the fact that the same people who were officers of the new bank were also officers of the Lewis Publishing Company and the University Heights Realty & Development Company, as well as of other Lewis enterprises. Soon, the US postmaster general accused Lewis of fraud and, on July 6, 1905, stopped all of the bank's incoming mail, returning it to senders with the word "Fraudulent" stamped in red across the envelope. People's United went into receivership. But Lewis already had new plans for his marble-sheathed behemoth—a national daily. (Archives of the University City Public Library.)

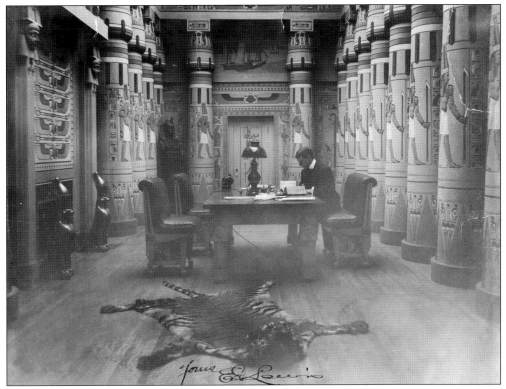

WOMAN'S NATIONAL DAILY BUILDING (INTERIOR), 1905. Here is Lewis at his desk in the President's Office. At the time the postmaster general closed the People's United States Bank, he had tried, unsuccessfully, to rescind the second-class mailing privileges used for all Lewis publications, charging that they were advertising circulars, not magazines, so not eligible for the lower rate. Early in 1907, however, he was successful in a second attempt. Lewis was ruined. (Archives of the University City Public Library.)

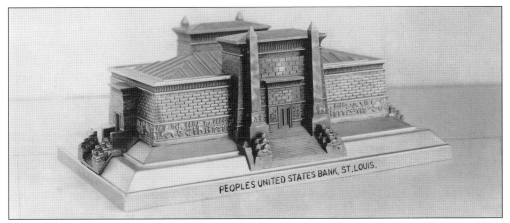

PEOPLE'S COIN BANK, 1904. This nickel- and copper-plated model of the planned bank building was initially intended to introduce children to the joys of saving. When the People's United States Bank was closed and thrown into receivership, Lewis recovered the costs of these little savings banks by selling them for $1.50 through his magazines. The advertisements were headlined, "Lest We Forget!" (Archives of the University City Public Library.)

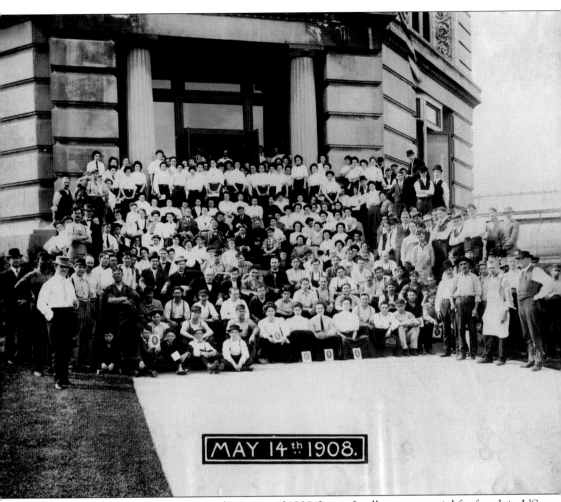

MAY 14th 1908.

WELCOME HOME, BOSS, 1908. In the spring of 1908, Lewis finally went on trial for fraud, in US district court in St. Louis. On May 14, at the end of the trial, the judge directed a verdict of not guilty. By this time, Lewis's case, with its implications of serious political corruption, had drawn national attention; the postmaster general's activities regarding Lewis had been the subject of a rebuke by the US House of Representatives. While Lewis sometimes incorrectly regarded the money in the accounts of his various enterprises as fungible, he was now dead broke, his subscription lists severely damaged by the prolonged loss of his second-class mailing privileges. But his employees seemed glad to have him back, and, being E.G. Lewis, he had already worked out a plan that would simultaneously revive his failing subscription list and promote the hot topic of women's suffrage. (Archives of the University City Public Library.)

AMERICAN WOMAN'S LEAGUE, 1907. In December 1907, in an effort to rebuild his subscriber base, Lewis created the American Woman's League (AWL) as a subscription-gathering organization for his magazines and affiliated publications. At that time, it was not uncommon for publishers to pay a fee to those selling subscriptions. To qualify for membership in the AWL, an individual had to pay $52 cash or sell at least $52 in magazine subscriptions. The fees that ordinarily would have been paid to the individual would instead be paid to the AWL. The organization used these funds to promote educational, cultural, and business opportunities for women. (Archives of the University City Public Library.)

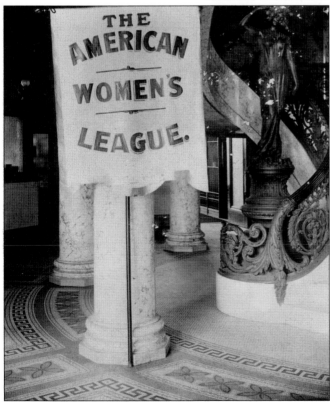

AWL MEMBERS' BENEFITS, 1907. Lewis promised benefits that modern women wanted: a People's University offering dozens of correspondence courses, and AWL chapter houses built in small towns across the United States, each intended to provide women a community center for cultural, educational, and social events. Lewis had struck a nerve; AWL membership ballooned to an estimated 700 chapters across the country. Lewis was back in business. The banner should read "The American Woman's League." (Archives of the University City Public Library.)

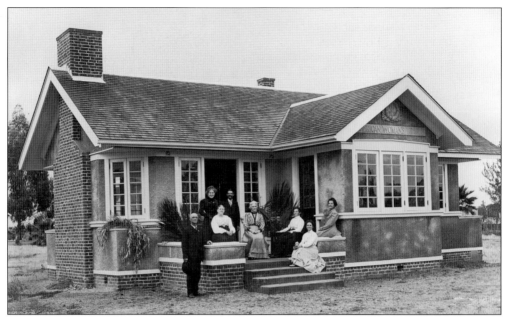

AWL Chapter House, Corning, California, 1910. Part of the AWL's appeal to many women was the idea of the chapter house. If a chapter met certain qualifications, the AWL would build and furnish, for free, a chapter house on a lot provided by the chapter. The chapter house represented a haven where women could meet and discuss the issues of the day without being scorned by men for expressing their opinions. Women's suffrage was still a few years away, but AWL women were being given a head start on what lay ahead. (Archives of the University City Public Library.)

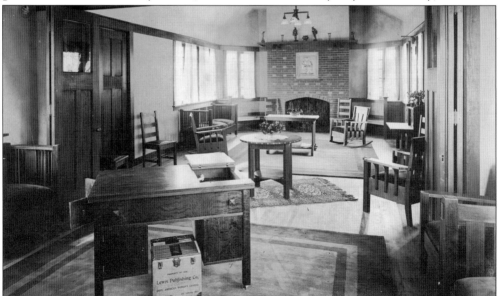

AWL Chapter House, Edwardsville, Illinois, 1909. This was the first AWL chapter to receive a chapter house. In addition to carpets and a handsome set of Mission-style furniture, the AWL also provided a phonograph and maintained a lending library of records that circulated among the chapters in packing cases like the one shown beneath the phonograph in the foreground. (Archives of the University City Public Library.)

MR. MAYOR, 1907. Lewis wanted to make sure that his planned subdivisions would remain the model neighborhoods he envisioned. A municipal government offered the best instrument of protection, so Lewis led a drive to have the area around the Delmar Loop incorporated as a city. His efforts were successful, and on September 6, 1906, the City of University City, Missouri, was born. Lewis was elected its first mayor and served three terms. (Archives of the University City Public Library.)

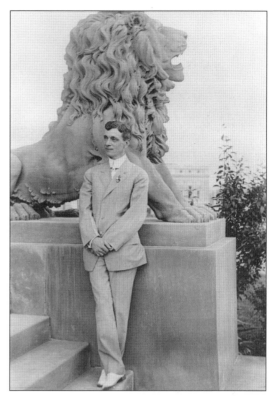

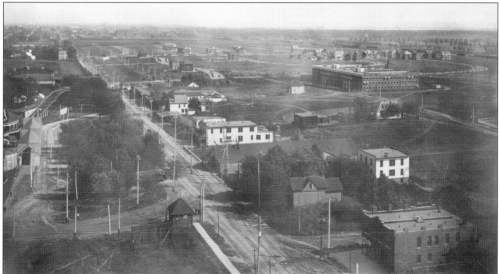

DELMAR LOOP, 1907. The mayor was not happy with the appearance of the Loop (here looking east), especially of the south side of the 6600 block of Delmar Boulevard directly opposite the Delmar Garden amusement park and the ever-problematic Delmar Race Track. There were saloons, dance halls, and other dubious entertainment venues. The dance halls were the first to go; Mayor Lewis levied a monthly tax of $500 on them. Whatever the ambience, the Delmar streetcar continued its graceful loop through the southwest corner of Delmar Garden. (Archives of the University City Public Library.)

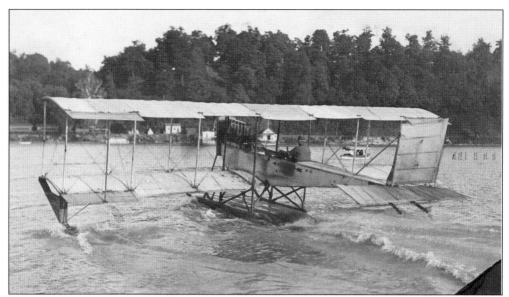

LOOP AIRPLANE FACTORY, 1907. Thomas W. Benoist, operator of one of the first aviation supply houses in the United States, set up shop in one of the erstwhile dance halls on the south side of the 6600 block of Delmar. A pilot, he began to design and build planes there. When a fire destroyed his building and several planes, he was back in business a few doors east within a week. Here, one of his float planes is taxiing on Creve Coeur Lake. (Missouri History Museum.)

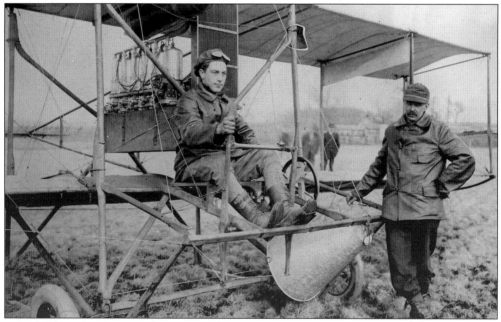

AVIATION FIRSTS, 1912–1917. Benoist aircraft figured in several US aviation firsts: On March 1, 1912, the first parachute jump from a powered plane with pilot Antony Jannus (left) and parachutist Capt. Bert Berry; (1912) first long-distance flight in a float plane from Omaha to New Orleans; (1914) first commercial airline flights—two daily scheduled round-trips, Tampa to St. Petersburg, aboard Benoist-designed float planes. Benoist's remarkable career was cut short when he was killed in a freak street car accident in 1917. (Missouri History Museum.)

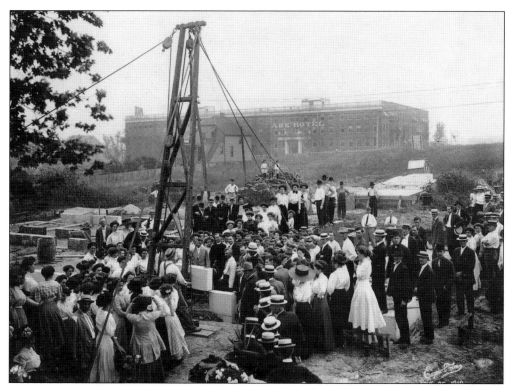

CITY HALL CORNERSTONE, 1910. In 1909, University City residents passed a bond issue funding construction of a city hall. On August 25, 1910, Mayor Lewis and citizens of the new city gathered to lay the cornerstone for the new building at 6618 Delmar. The Reverend James Long, pastor of All Saints Church whose parishioners had helped bring the vote to incorporate over the top, gave the prayer. The Park Hotel is in the background. (Archives of the University City Public Library.)

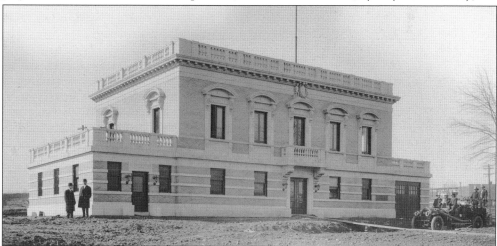

CITY HALL, 1911. The architecture firm Helfensteller Hirsch and Watson designed the new building, which replaced the city government's temporary digs in the Magazine Building. The police department was quartered in the building's east wing, and the fire department was situated in the west wing. The new Robinson fire engine is parked in front of the fire station, with Mayor Lewis himself at the wheel. (Archives of the University City Public Library.)

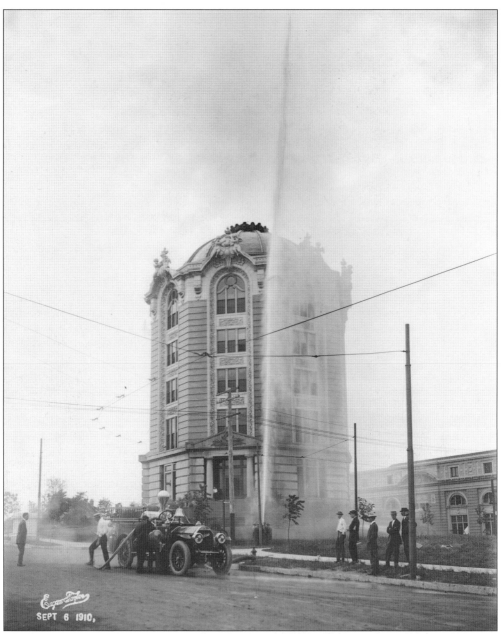

FIRE ENGINE DEMONSTRATION, 1910. In 1909, University City residents also passed a bond issue for funds to purchase a fire engine. In September 1910, a $9,000 state-of-the-art fire engine built by the Robinson Fire Apparatus Company of St. Louis was delivered. Here, firemen test how tall a plume of water the new apparatus could throw. The result: a column of water 58 feet higher than the 135-foot Magazine Building. (Archives of the University City Public Library.)

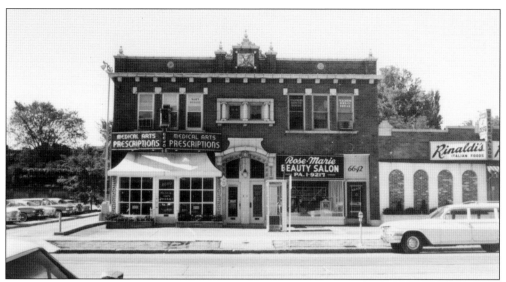

BOND BUILDING, CONSTRUCTED IN 1910. This is the oldest surviving building in the Loop. Located at 6640 Delmar, it was built by Max Bond in 1910 for his tailor shop with apartments above. Over the years, the building has housed a variety of businesses, including the drugstore and beauty salon shown in this 1965 photograph. Craft Alliance, nationally known for its gallery, studios, and programs, has occupied the building since 1970. (Archives of the University City Public Library.)

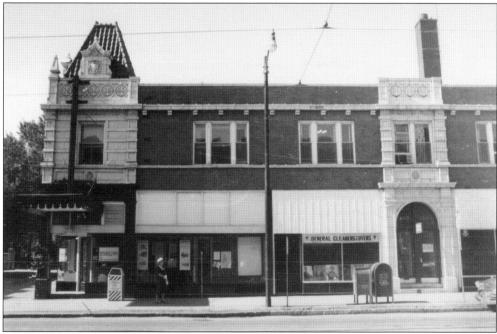

SMITH BLOCK, CONSTRUCTED IN 1911. The second oldest building in the Delmar Loop is the Smith Block. Designed by Edward F. Nolte, it is a full block long, stretching west from Westgate to Melville with offices above and retail space at street level. In this 1960 photograph, University City's Land Clearance and Redevelopment Authority office occupies a corner storefront. Today, Blueberry Hill, the popular restaurant and music club, occupies the entire building. (Archives of the University City Public Library.)

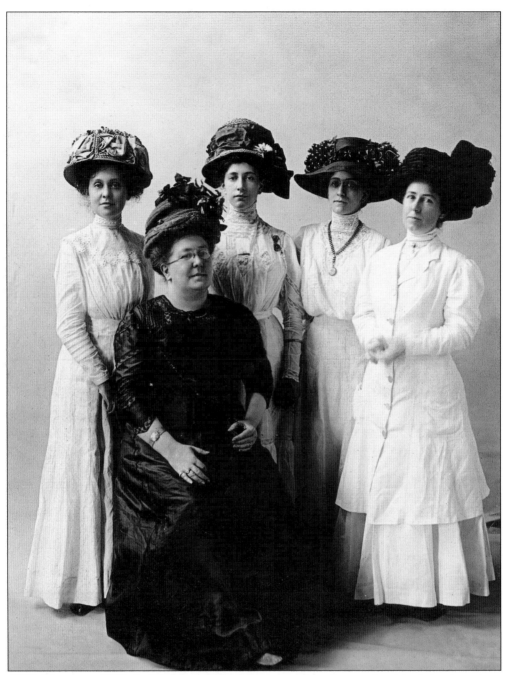

AWL MEMBERS, 1909. In 1909 and 1910, chapter members frequently visited the American Woman's League headquarters in the Magazine Building in University City. The chapter to which these five women belonged is not identified, but it seems certain they were already making plans to attend the first annual AWL convention, planned for June 9–10, 1910, in University City. (Archives of the University City Public Library.)

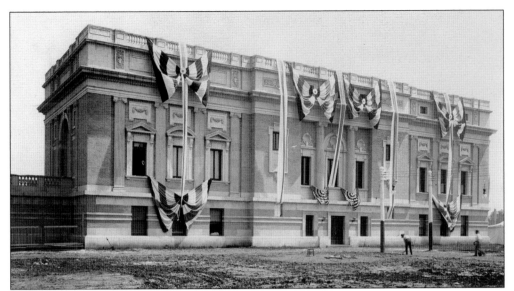

People's University Art Academy, 1910. The Art Academy was the first and only building constructed on the People's University's projected campus. Art students who showed great promise in AWL correspondence classes could win scholarships to study at the Art Academy. Lewis had managed to assemble a truly stellar faculty, even as, behind the scenes, his house of cards was tumbling. Here, the building, designed by architects Eames and Adams, is decorated for the 1910 AWL convention. (Archives of the University City Public Library.)

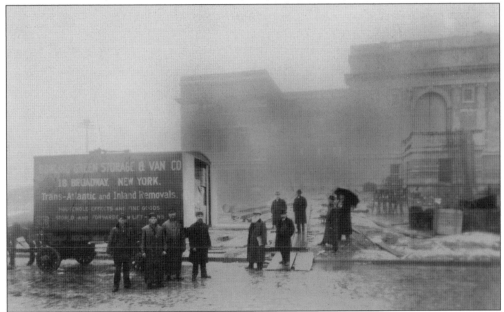

Doat's Collections Arrive, January 1910. Lewis convinced Taxile Doat, a famous potter, to come from France to head the Art Academy's ceramics department, and to sell the academy his personal ceramics collections for permanent display. Here, workers prepare to unload the precious cargo. Doat is standing behind the van, left of planks laid over the curb. It was a rainy day, perhaps a gloomy foreshadowing of the academy's short life. Later, as Lewis's bankruptcy became inevitable, the collections were sold. (Archives of the University City Public Library.)

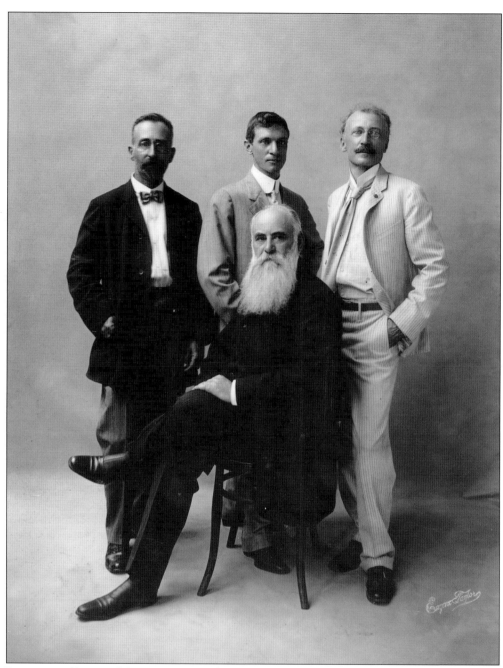

LEWIS WITH FACULTY MEMBERS, 1910. This portrait of Lewis and some of the artists associated with the Art Academy of the People's University was taken in early 1910. Seated is Taxile Doat, whose book *Grand Feu Ceramics*, published in 1905, had helped introduce the Art Nouveau style to fine porcelain. Samuel Robineau (left) was a ceramics instructor who had translated Doat's work into English. Lewis (center) had read Doat's book, and this sparked Lewis's hands-on interest in fine pottery. George Julian Zolnay was the director of the Art Academy and had sculpted the Lion Gate's lions. Earlier, Zolnay had served as head of the 1904 World's Fair art department. (Archives of the University City Public Library.)

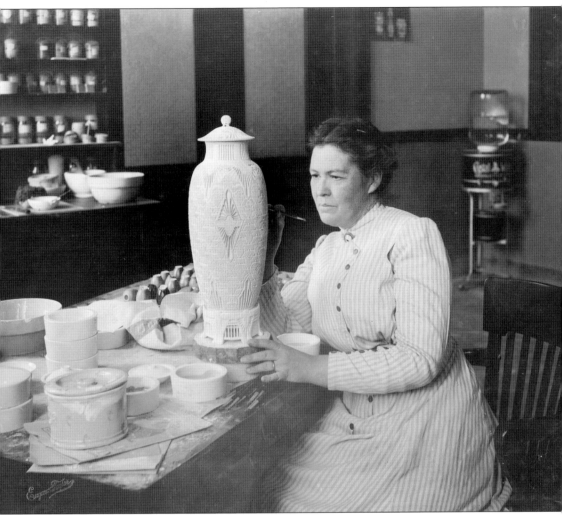

ADELAIDE ALSOP ROBINEAU, 1910. Lewis persuaded Robineau, a student of Doat's and considered one of the most talented ceramic artists in America, to come to the academy to teach and also experiment with new clays and glaze techniques. Here, she is at the academy, carving a section of the scarab vase that won her international fame. In its March 2000 issue, *Arts and Antiques* magazine called *The Scarab Vase* "the most important piece of American ceramics in the past century." She and her husband, Samuel Robineau, launched *Keramic Studio*, a pioneering periodical for ceramic artists and potters. At the time of Robineau's death in 1929, the Metropolitan Museum of Art conducted a memorial exhibition of her porcelain and stoneware. (Archives of the University City Public Library.)

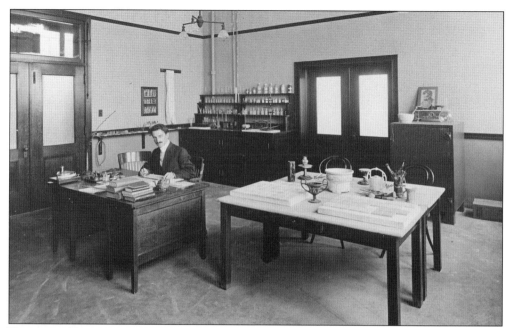

FREDERICK HURTEN RHEAD, 1910–1911. A native of England who worked as a potter in the United States for most of his career, Rhead was a compelling force in both studio and commercial pottery. He worked for Rosedale Pottery, established his own Rhead Pottery in 1913 after the collapse of the Art Academy, and, in 1935, designed the much-loved "Fiesta Ware" for Homer Laughlin China. (Archives of the University City Public Library.)

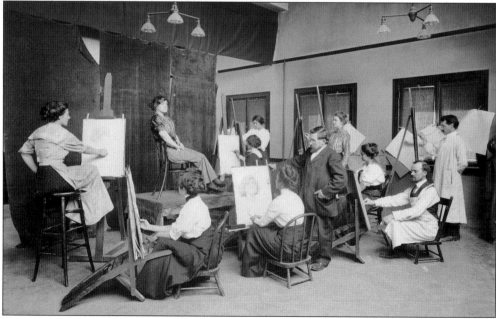

JOHN VANDERPOEL, 1910. Another artist wooed to the Art Academy by Lewis was John Vanderpoel, one of America's foremost authorities on figure drawing. His book *The Human Figure*, published in 1907, became a standard text for art students. Here, Vanderpoel (center, in jacket) is conducting a figure-drawing class in which Mabel Lewis is the model. (University City Public Library Archives.)

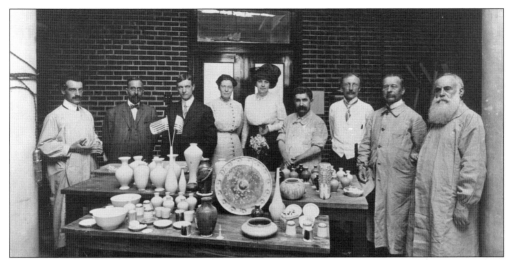

AN AUSPICIOUS MOMENT, 1910. On April 4, 1910, the first kiln of high-fire porcelains was successfully fired at the Art Academy of the People's University. All the pieces on the table came from that first kiln. The happy participants gathered for the photograph are, from left to right, Frederick H. Rhead, Samuel Robineau, Edward Gardner Lewis, Adelaide Alsop Robineau, Mabel Gertrude Lewis, technician Eugene Labarriere, George Julian Zolnay, technician Emile Diffloth, and Doat. Work from this short period is in the collections of several museums, including the St. Louis Art Museum, and is also on display in the University City Public Library. (Archives of the University City Public Library.)

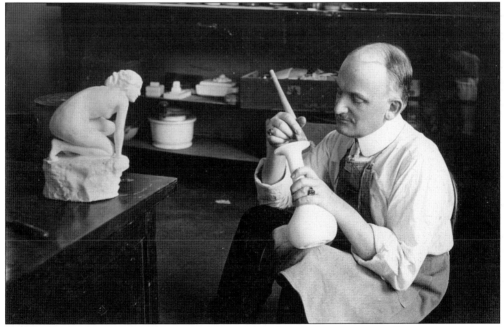

A LESS AUSPICIOUS TIME, 1912–1913. Here, an unidentified artist is at work on a vase in one of the academy studios that had become the University City Pottery. By 1912, in desperate need for money, Lewis turned academy emphasis from fine art pottery to commercial ware that could be mass-produced. The figure on the table was made from a mold, and that was probably also the case with the vase being decorated. (Archives of the University City Public Library.)

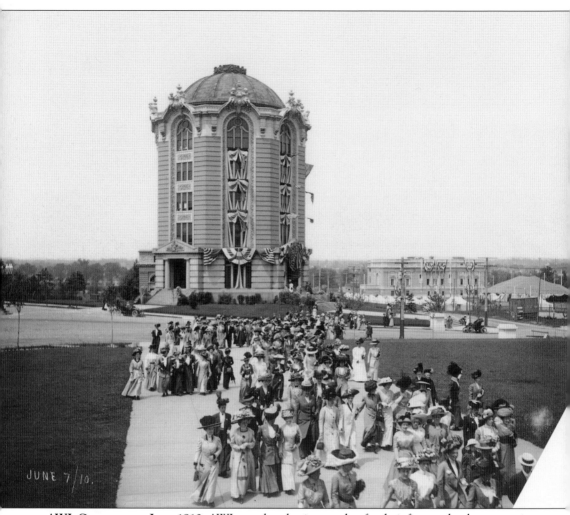

JUNE 7/10.

AWL Convention, June 1910. AWL members begin to gather for their first, and only, convention, held on June 9 and 10 in University City. (Archives of the University City Public Library.)

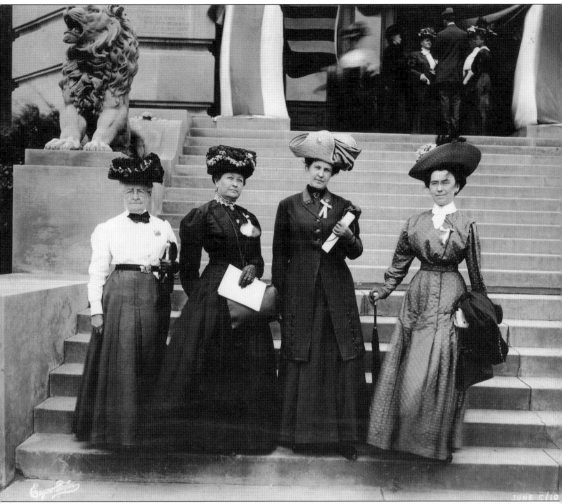

AWL Chapter Presidents, June 1910. A random group of AWL chapter presidents shows the already wide geographical spread the AWL had reached in its short life. Pictured here are, from left to right, Amelia D. Ball of the Montague Chapter in Massachusetts; Nada Ingraham of the McKinley Chapter in Fort Worth, Texas; Mabel Bryant of the Mountain Gem Chapter in Clarkston, Washington; and Mrs. Otis Turner of the La Fresneda Chapter in Fresno, California. (Archives of the University City Public Library.)

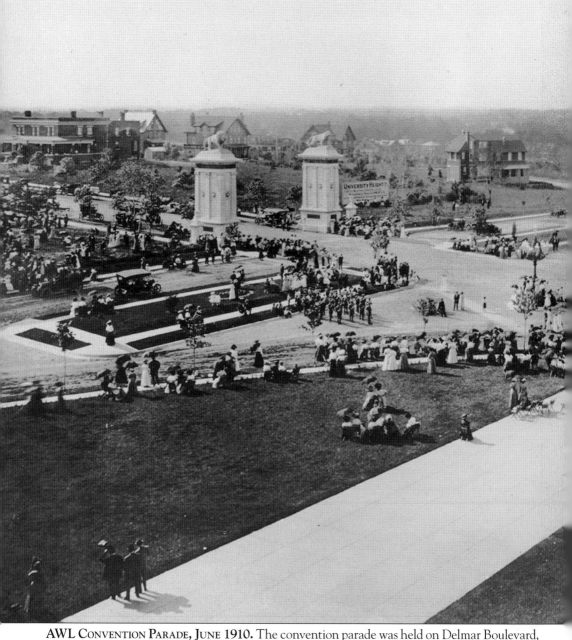

AWL Convention Parade, June 1910. The convention parade was held on Delmar Boulevard, on the plaza between the Magazine Building and the Woman's National Daily Building. Floats were built by students under the guidance of George Julian Zolnay, Art Academy director. In this photograph, the Magazine Building is on the right and the Lion Gates, topped by Zolnay's

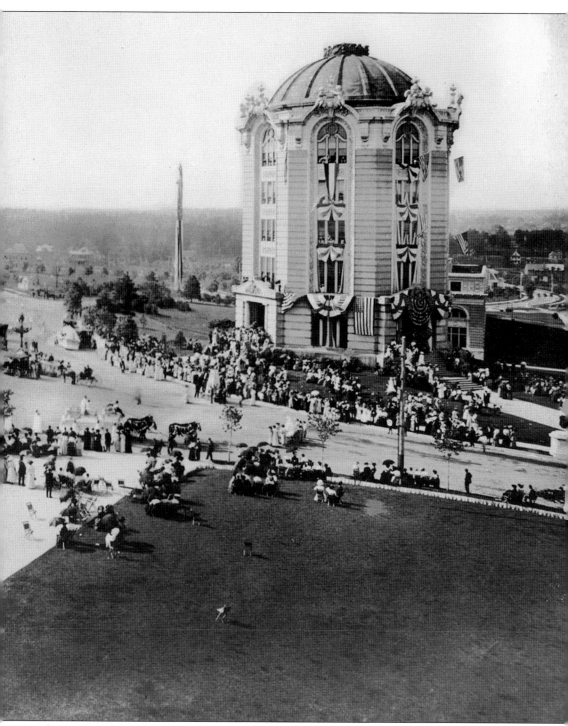

sculptures, are the truly handsome "Gates of Opportunity." The billboard next to the Lions Gate is promoting University Heights subdivisions. Several houses in University Heights are visible just beyond the Lion Gates. (Archives of the University City Public Library.)

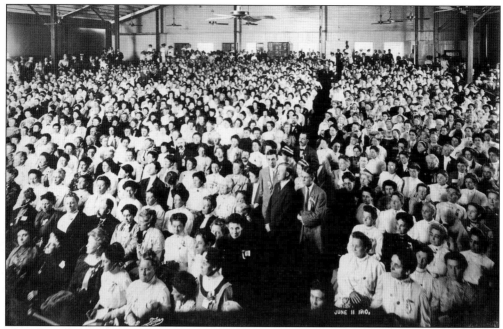

MASS MEETING OF AWL CONVENTIONEERS, JUNE 1910. This meeting on the final day of the convention had to be held indoors because of rain. Fortunately, the theater in the Delmar Garden amusement park was available and still a respectable venue. The park finally closed for good in 1919, the AWL a little sooner than that. (Archives of the University City Public Library.)

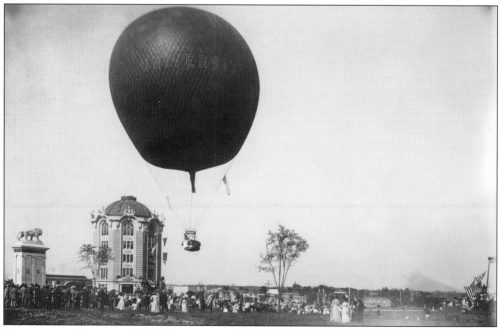

CONVENTION FINALE, 1910. The event-packed convention ended on a high note with the spectacular ascension of the gas balloon *University City*, piloted by renowned Capt. John Berry. By then, though, the AWL was already in financial trouble and struggling to keep its promises to its members. (Archives of the University City Public Library.)

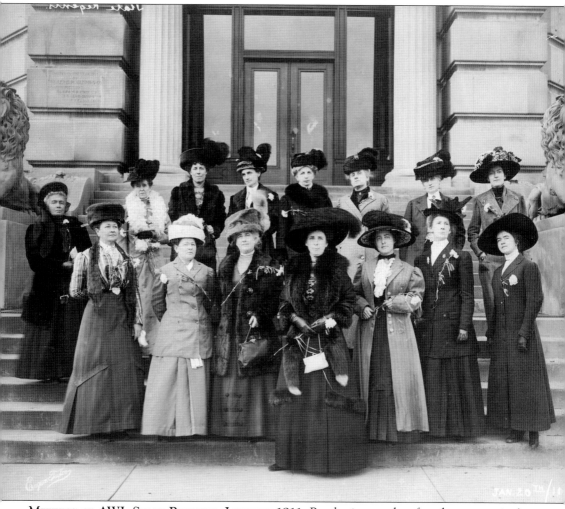

MEETING OF AWL STATE REGENTS, JANUARY 1911. Barely six months after the convention's end, concern about the business affairs of the AWL resulted in the election of state regents, who gathered for an organizational meeting in University City on January 11, 1911. There, it was decided that the AWL would establish a parallel organization more directly devoted to women's suffrage, which was nearing reality. The AWL was, in effect, reorganized into the American Woman's Republic (AWR), modeled on the US government. Its stated purpose: prepare women for the roles they would soon assume in government. Mabel Lewis was elected its first president. (Archives of the University City Public Library.)

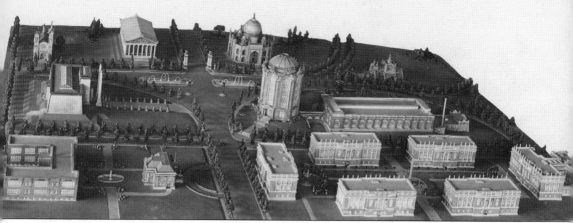

AMERICAN WOMAN'S REPUBLIC, DELMAR LOOP, 1911. Over the years, whatever the situation in which Lewis found himself, good or bad, he always had a plan, sometimes good, sometimes bad. The AWR, a distinct political entity, needed a capital city; Lewis proposed, scale model in hand, that it be located in University City at the west end of the Delmar Loop. Lewis's model remains on view in the lobby of University City's City Hall. Structures actually built are, clockwise from the Magazine Building and its Press Annex, (right lower corner) the Art Academy; (extreme left center) the Woman's National Daily building; and (upper left corner) University United Methodist Church. (Archives of the University City Public Library.)

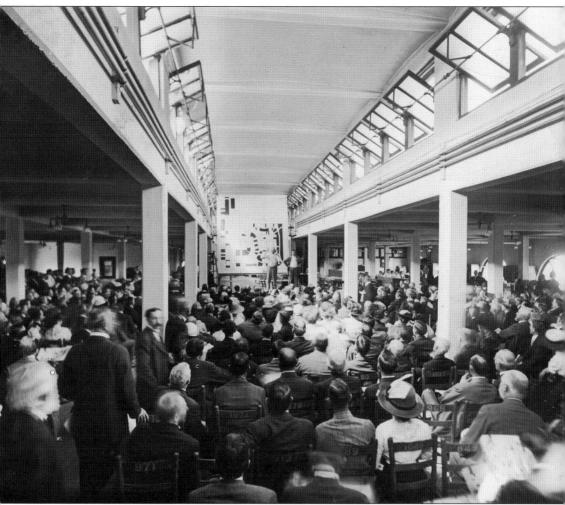

FALL OF THE HOUSES OF LEWIS, 1912. Edward Gardner Lewis's tangled web of enterprises and finances at last began its fatal collapse. University Heights Realty & Development Company, the real estate firm owned by Lewis and other investors, had been issuing stock certificates since early 1903. The company continued in operation until 1912, when all of Lewis's companies were forced into bankruptcy. On May 8, 1912, lots owned by the company in University Heights No. 1, No. 2, and No. 3 subdivisions were sold at a public auction held in the Press Annex. (Archives of the University City Public Library.)

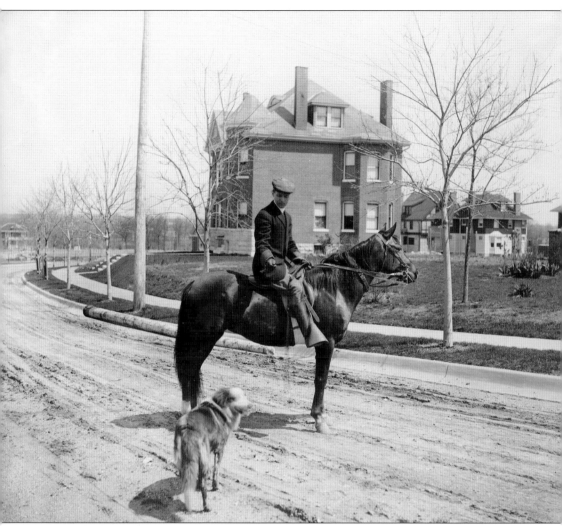

LEWIS IN QUIETER TIMES. Edward Gardner Lewis never met an opportunity he did not like and for which he could not cobble together the finances, at least temporarily, to bring it to fruition. Here he is, in a quieter time, the Squire of Yale Avenue, with horse and dog, surveying the developing model subdivision he had imagined. He left University City altogether in 1913 for Atascadero, California, where he bought a 24,000-acre ranch, founded a utopian colony for the American Woman's Republic, designed an automobile-friendly community, built one of the earliest versions of an indoor shopping mall, published the *Illustrated Review*, a photographic news magazine, built the largest factory in the world for the dehydrating of vegetables, and generally kept his face to the sunshine. (Archives of the University City Public Library.)

Two

MODERN TIMES

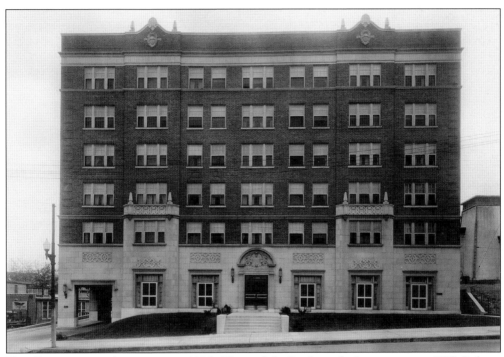

THE CASTLEREAGH APARTMENTS, 1925. The stylish Castlereagh Apartments at 6820 Delmar Boulevard, designed by Preston Bradshaw, architect of the Chase and Mayfair hotels, added a touch of sophistication to the western end of the Loop. It also represented the area's distinct new era, standing as it did for several years within touching distance (extreme right of photograph) of the forlorn Egyptian Building. If the old building was a reminder of E.G. Lewis, whose financial crash had also left city finances in tatters, the new building perhaps spoke of better times to come. In 1930, the Egyptian Building was bought by congregation Shaare Emeth, the first of the large Jewish congregations to move west to University City. The congregation had intended to remodel it and use it as its temple, but the monumental old building proved intractable and was torn down. A fine new Temple Shaare Emeth was built on the Egyptian Building's site. (Archives of the University City Public Library.)

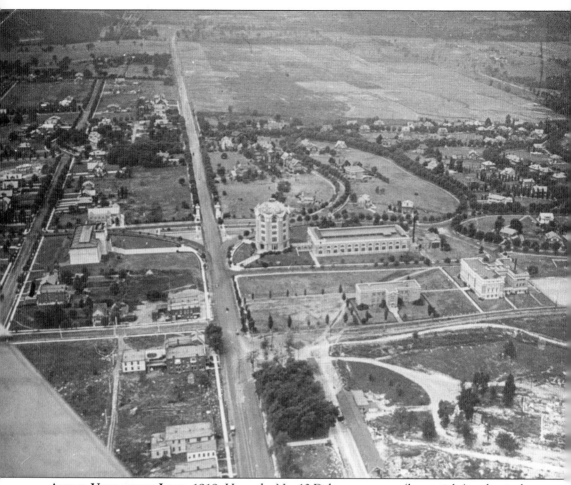

AERIAL VIEW OF THE LOOP, 1918. Here, the No. 10 Delmar streetcar (lower right) makes its loop toward downtown past a noticeably diminished Delmar Garden amusement park. University Heights No. 1's curving streets are in the upper left, while University Heights No. 2 and No. 3 are developing across Delmar from the former Magazine Building. The land west of the Loop remained largely undeveloped well into the 1920s. The succession of mayors in office after Lewis may not have had imaginations as grand as his, but they stabilized the city finances, established a planning commission, installed a modern sewer system, supported the growing excellence of the University City school system, and began a system of parks throughout the city. Numbers of handsome public and private buildings dotted the landscape of the growing city. As the business district along the Delmar Loop expanded, the streetcar lines serving University City brought hundreds, perhaps thousands, of commuters to its shops, restaurants, and movie theaters each day. In 1919, Lewis's final hurrah to University City came when the Orcutt Moving & Storage Company bought the signature buildings of his old empire: the Magazine Building, the Press Annex, and the Egyptian Building. (Archives of the University City Public Library.)

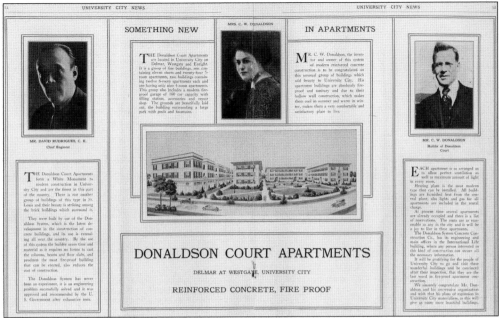

SOMETHING NEW

MRS. C. W. DONALDSON

IN APARTMENTS

MR. DAVID RUDRIGUES, C. E.
Chief Engineer

MR. C. W. DONALDSON
Builder of Donaldson
Court

DONALDSON COURT APARTMENTS

DELMAR AT WESTGATE, UNIVERSITY CITY

REINFORCED CONCRETE, FIRE PROOF

DONALDSON COURT APARTMENTS, 1922. This complex of four buildings at 6501–6525 Delmar Boulevard and 605–615 Westgate Avenue was built using an innovative system of poured-in-place reinforced concrete invented by its developer, Charles W. Donaldson. Its residential entrances are on Westgate, although the southernmost building stretches along the 6500 block of Delmar and contains popular retail shops and restaurants at street level, with apartments above. (Archives of the University City Public Library.)

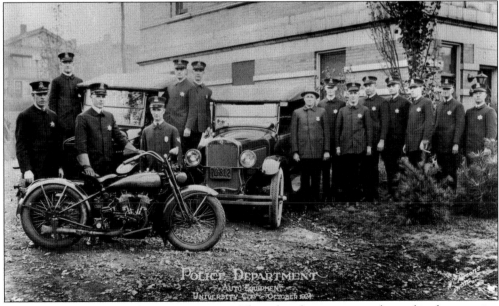

UNIVERSITY CITY POLICE DEPARTMENT, 1924. The police department was located in the east wing of city hall at 6618 Delmar Boulevard. Here, officers proudly display the department's modern motorized fleet, including a motorcycle for the city's first traffic cop. (Archives of the University City Public Library.)

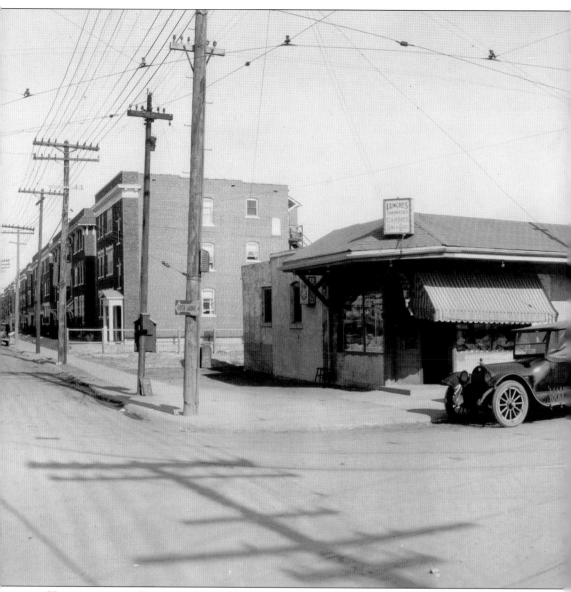

KINGSLAND AND ENRIGHT, 1923. The corner of Kingsland and Enright Avenues, part of the No. 10 Delmar streetcar loop, was a veritable transportation hub. The streetcar on the right will turn left onto Kingsland and then out onto Delmar to return to downtown St. Louis. The single-story building at the corner is sign-posted "Delmar Loop Station" and has a shop offering, in addition

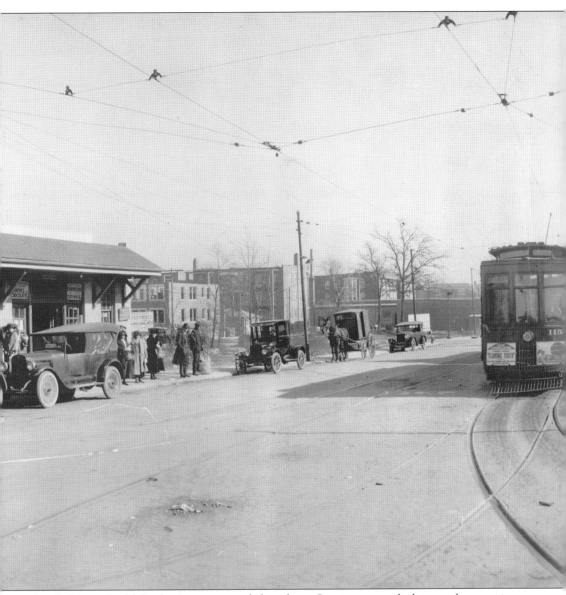

to lunch, hot and cold drinks, ice cream, and chocolates. Service cars and what may be a service horse and buggy wait in front of the station for travelers who preferred private transportation for the rest of their journey. (Archives of the University City Public Library.)

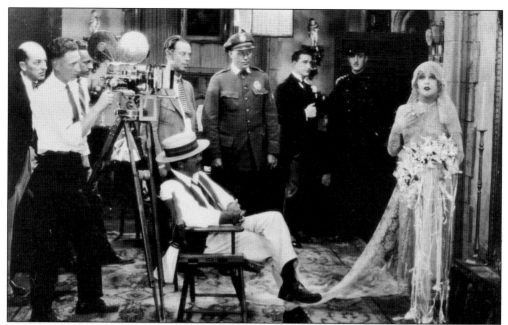

HOLLYWOOD IN THE LOOP, 1923–1926. The Egyptian Building, née the National Woman's Daily building, remained empty for long periods of time. Movie actor Romaine Fielding founded the General Film Manufacturing Company in the early 1920s, and in 1923, he moved into the Egyptian Building. There, he began producing short features, both comedies and melodramas. Pictured above, Fielding (seated) directs actress Joan Arliss and a cast of four, for better or for worse. (Archives of the University City Public Library.)

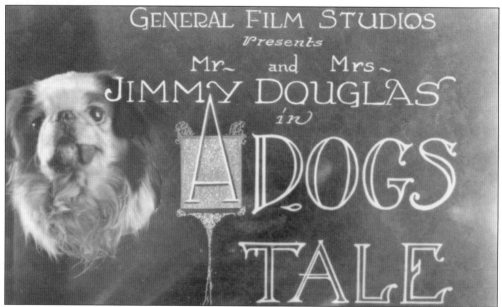

NOW PLAYING, 1923–1926. This is the title card for one of the silent films produced at General Film Studios in the Delmar Loop. There is no further information about Mr. or Mrs. Jimmy Douglas or the pooch. (Archives of the University City Public Library.)

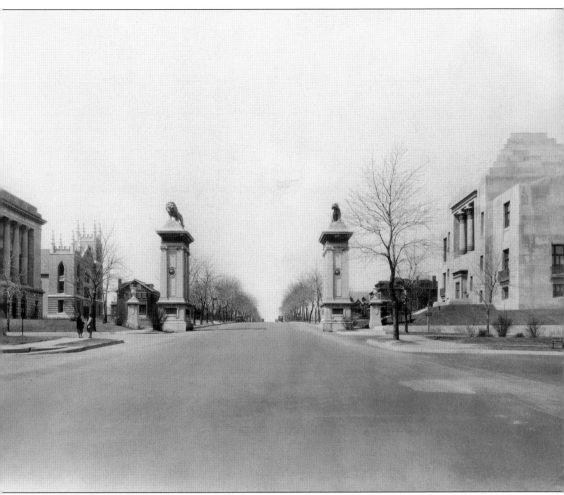

LION GATES LOOKING WEST, 1929. By the mid-1920s, two more imposing structures had been added to what came to be known as University City's Civic Plaza. The domed building on the left, at 6900 Delmar Boulevard, was built in 1924 as the First Church of Christ, Scientist. It was designed by architect Tom P. Barnett, who also designed the striking Egyptian-style building across the street at 6901 Delmar. Built in 1924–1925 for the University Temple Association, a Masonic organization, the structure was owned by Anchor Temple, a second Masonic organization, from 1935 until 1977, when it was bought by Childgrove School. The Church of Scientology is its current owner. (Missouri History Museum.)

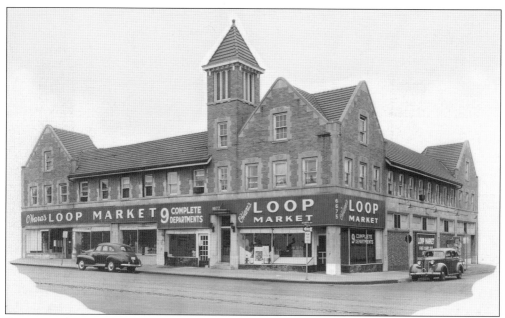

O'HARA'S LOOP MARKET, CONSTRUCTED IN 1923. The large grocery store at 6675 Delmar Boulevard was just one of several substantial retail structures built in the Loop in the 1920s. The business changed hands only three times in its long history. The building was demolished in 1973, and University City's open-air Market in the Loop was built on its site. The grocery's last owner, Martin Mantia, segued seamlessly into the job of market master for the new facility. (Archives of the University City Public Library.)

DELMAR GARDEN BUILDING, CONSTRUCTED IN 1925. This attractive building at 608 Kingsland, designed by architect Henry A. Wagner, is one of only two buildings left erected in the 1920s that were actually looped by the No. 10 Delmar. (The other is the former Bank of University City Building at 6633–6639 Delmar.) Although street car service to the Loop ceased on April 19, 1964, retail space in this highly visible building has rarely been vacant. In this 1990 photograph, Paul's Books occupies this prime location. (Archives of the University City Public Library.)

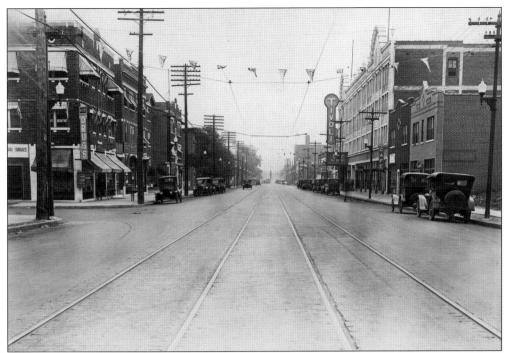

DELMAR BOULEVARD, 1925. This early photograph of the Delmar Loop business district, looking east, features the iconic sign of the popular Tivoli Theatre. Opened on May 24, 1924, the Tivoli was part of the Skouras brothers' highly successful chain of theaters. Spyros Skouras, later president of 20th Century Fox studios from 1942 to 1962, lived nearby in Ames Place for several years. (Archives of the University City Public Library.)

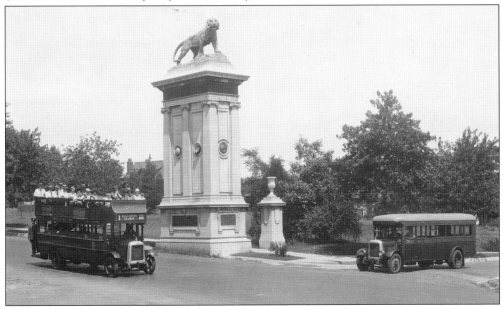

PUBLIC BUSES AT THE LION GATES, 1925–1928. Beginning in 1923, the People's Motor Bus Company operated the first bus lines intended to run in direct competition with streetcars. The company was bought out by the St. Louis Public Service Company in 1934. (Missouri History Museum.)

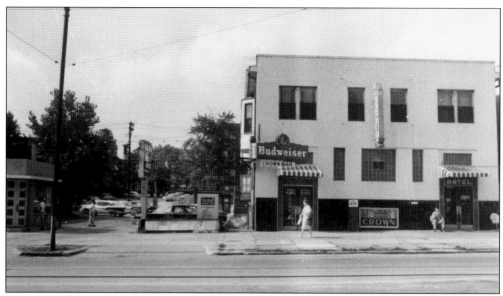

KINGSLAND HOTEL, 1928. The building, at 6668 Delmar Boulevard, opened in 1928 as the Berger Hotel. The Crown Bar at the building's corner had served as a restaurant from the building's earliest days, during the 1904 World's Fair. (Archives of the University City Public Library.)

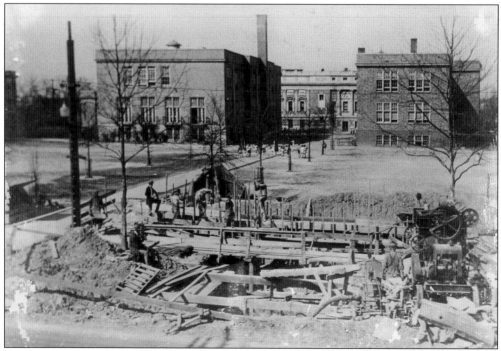

UNDERPASS CONSTRUCTION, 1929. In this photograph, an underpass is being constructed under Delmar Boulevard that will provide safe crossing for children attending the Delmar School (right), the Harvard School (left), and the University City High School (rear center), once the Art Academy Building of E.G. Lewis's People's University. Another underpass crossed busy Kingsland Avenue at the streetcar turnaround. The underpasses were used by schoolchildren and other pedestrians for more than 30 years. (Archives of the University City Public Library.)

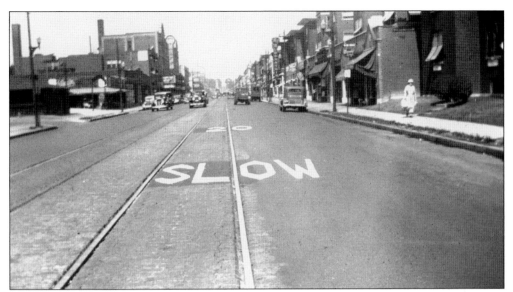

Delmar at Limit Avenue, 1930. Limit Avenue marks the boundary where St. Louis City ends and University City begins. It also marked where University City's new speed limit on Delmar Boulevard of 20 miles an hour would be enforced, probably by a police officer on a motorcycle. (Archives of the University City Public Library.)

The Loop, 1931. A No. 10 streetcar is making its way through the Loop, but the former Delmar Garden amusement site is now densely built up with multifamily residential buildings and shops that serve both the neighbors and streetcar commuters. (Archives of the University City Public Library.)

CORNER OF DELMAR AND KINGSLAND, 1930. A streetcar (upper left) is just coming out from behind the Delmar Garden Building and preparing to turn onto Kingsland and complete the Delmar Loop turn. The busy intersection does not have traffic lights, which is why using a pedestrian underpass (lower center) was a good idea. (Archives of the University City Public Library.)

THE DELMAR KINGSLAND CUTOFF, 1930. This photograph of the same intersection as shown above, with the addition of Adelaide Avenue (left) on the south side of Delmar Boulevard, was taken from the Delmar Garden Building. The large yard at right is the playground for the Delmar and Harvard schools and the site of today's University City Public Library. The Garden drugstore is in the building on the corner of Adelaide and Delmar; the University City US Post Office would later occupy the site. Up the hill on the left is the Castlereagh. It would take officials 40 years to reconfigure this intersection. (Archives of the University City Public Library.)

SMITH HARDWARE, 1930.
This is Smith's 6661 Delmar location, about half the size of the building at 6662 Delmar, its final location. Still, it had any product or service a University City household might need. (Historical Society of University City.)

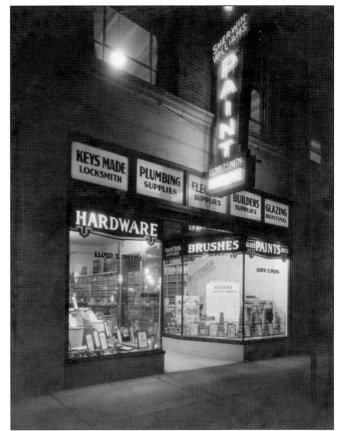

LASKY SHOE COMPANY, 1930.
Generations of families had their children fitted for new shoes at Lasky's. In the photograph below, taken about 1963, the beloved store is located at 6633 Delmar Boulevard. (Archives of the University City Public Library.)

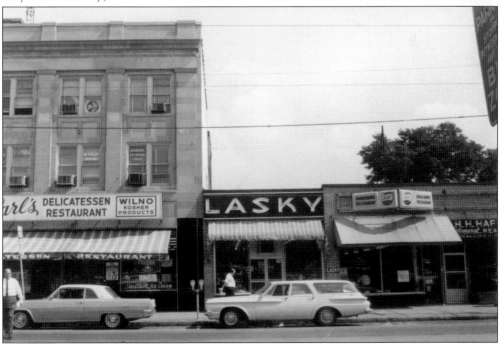

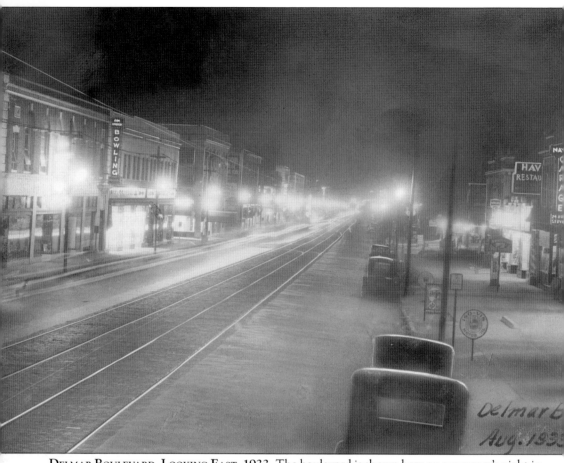

DELMAR BOULEVARD, LOOKING EAST, 1933. The boulevard is shown here on a summer's night in 1933. The bowling alley on the left was located at 6651 Delmar Boulevard, and Mayer's Garage was across the street at 6660 Delmar, at just about where Tom Benoist had one of his airplane factories 25 years before. (Archives of the University City Public Library.)

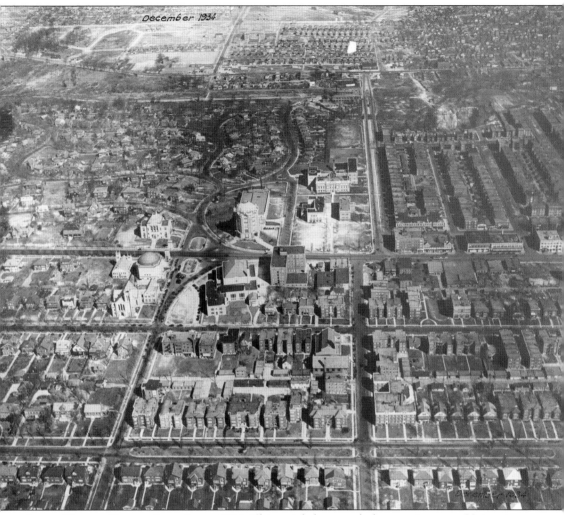

December 1934

AERIAL VIEW OF DELMAR LOOP AREA, 1934. This aerial photograph shows, at its center, University City's Civic Plaza. Though it resembles only in part Lewis's model of the proposed American Woman's Republic capitol, the Civic Plaza is an impressive array of buildings. Starting clockwise from city hall, they are (across Delmar) at 6820 Delmar, the Castlereagh Apartments (1925); at 6848 Delmar, the imposing Temple Shaare Emeth and Hebrew School building (1931); (across Trinity) at 6901 Washington, the University United Methodist Church (1913 and 1925); at 6900 Delmar, the domed First Church of Christ, Scientist (1924); next to it at 6910 Delmar, the University Church of Christ (1927) which was bought in 1936 by Tpheris Israel Congregation; and (across Delmar) at 6901 Delmar, Anchor Temple (1925–1926), a Masonic organization. (Archives of the University City Public Library.)

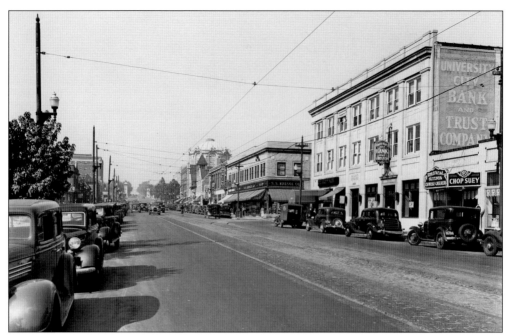

DELMAR LOOP, 1935. Looking west along Delmar Boulevard from Melville Avenue, it is clear to see that, despite the Depression, the Loop is busy. Visible in the photograph are dozens of cars, a bank, a chop suey restaurant, the five-and-dime store, and, overlooking it all, the octagonal City Hall. (Archives of the University City Public Library.)

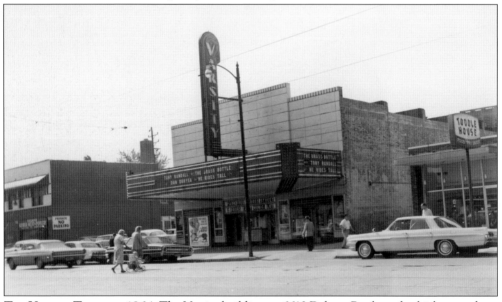

THE VARSITY THEATRE, 1964. The Varsity building, at 6610 Delmar Boulevard, which started out as an automobile repair shop, was a popular Loop destination. It opened as a theater in 1935. In this photograph, it still has its original sign and marquee, but that would change as redevelopment of the Loop began in the 1960s. Times may have been hard, but a movie followed by a snack at everybody's favorite, the Toddle House restaurant next door, made for a pleasant outing. After all, "just around the corner, there's a rainbow in the sky." (Historical Society of University City.)

Three

UPTOWN CONVENIENCE

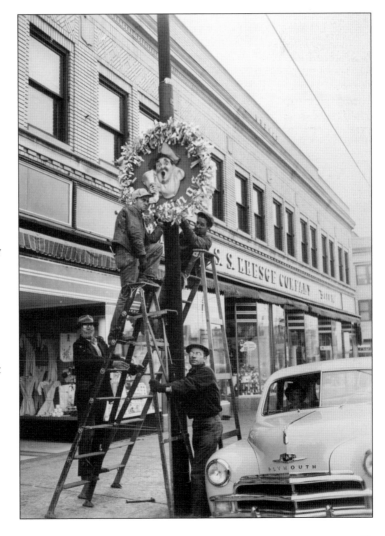

HANGING THE HOLIDAY DECORATIONS, 1940s. By the middle of the 1930s, the roomy apartments around the Loop, once filled with Catholic families, now were home to Jewish families. But since most faiths held some kind of celebration toward the end of each year, "holiday decorations" fit the bill for a busy shopping street such as the Delmar Loop. (Archives of the University City Public Library.)

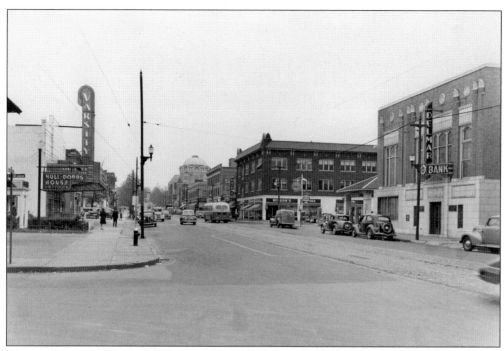

DELMAR LOOP, 1945–1946. While some wartime rationing was still in effect, nothing seemed sweeter than a matinee at the Varsity and supper afterwards at the Huff-Dobbs Restaurant. Across the street at 6605 Delmar Boulevard, the Delmar Bank, formerly the West End Bank, had been in the Loop at one address or another since 1913. In 1969, the Delmar Bank became part of the Commerce Bank family. (Archives of the University City Public Library.)

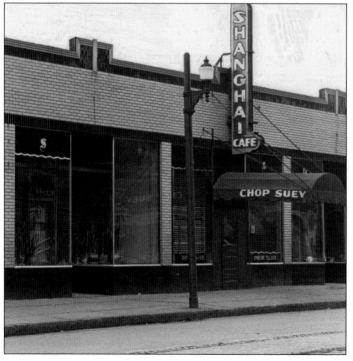

SHANGHAI CAFÉ, 1948. A restaurant, a photography shop, and Bob's Pet Shop shared this building (later the home of Streetside Records) at 6312–6314 Delmar Boulevard in 1948. The Shanghai stayed open on Saturday nights until 3:00 a.m. for late-night revelers needing a chow mein fix. (Archives of the University City Public Library.)

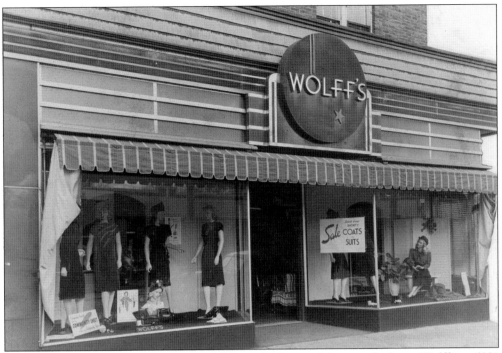

WOLFF'S APPAREL COMPANY, 1948. One of four ladies' apparel shops in the Loop, Wolff's, at 6301 Delmar Boulevard, advertised itself as a delightful combination of "Downtown Service, Uptown Convenience." Like many of the Loop's quality shops, Wolff's was open three nights a week until 9:00 p.m. (LCRA Collection, archives of the University City Public Library.)

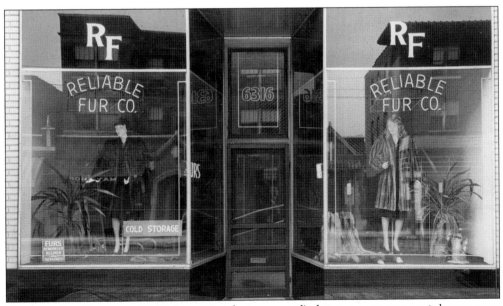

RELIABLE FUR COMPANY, 1948. In a time when every girl's dream was to own a mink coat, or at least a mouton stole, Reliable Fur not only stocked these dream garments but also took care of the services such garments required: cold storage, remodeling, relining, and repairs. It was located at 6316 Delmar Boulevard. (LCRA Collection, archives of the University City Public Library.)

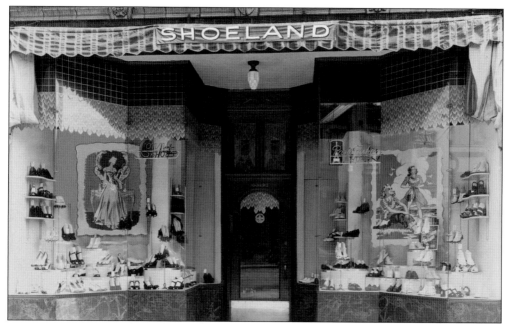

SHOELAND, 1948. While there were several other shoe stores in the Loop, Shoeland was the only shop that catered exclusively to women. It was located at 6319W Delmar Boulevard. And, like most stores in the Loop, it was open until 9:00 p.m. three nights a week. (LCRA Collection, archives of the University City Public Library.)

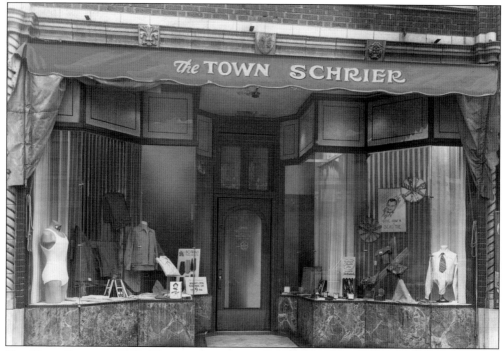

THE TOWN SCHRIER, 1948. This was the only men's clothing store in the Loop in 1948. Located at 6319E Delmar Boulevard, it carried only top national brands and featured impeccable customer service. (LCRA Collection, archives of the University City Public Library.)

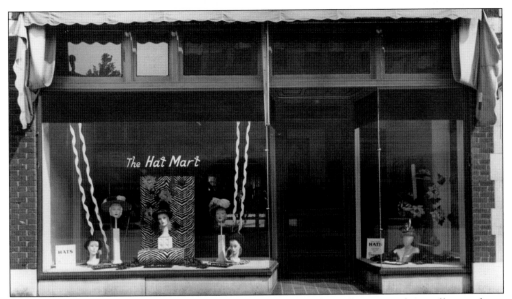

THE HAT MART, 1948. At the time this photograph was taken, there were four millinery shops in the Loop. The Hat Mart, however, was the only one offering "French Room Originals." The store was located at 6327 Delmar Boulevard. (LCRA Collection, archives of the University City Public Library.)

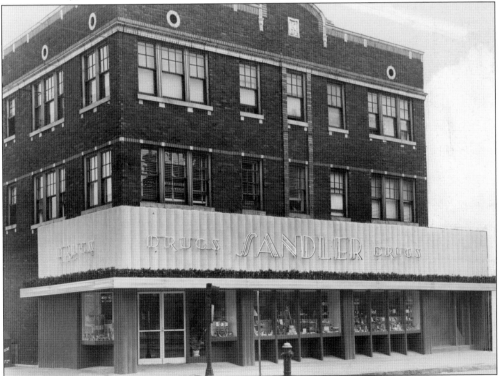

SANDLER DRUGS, 1948. The drugstore building at 6335 Delmar Boulevard was constructed about 1923. The owner, like other owners of aging buildings in the postwar years, "modernized" the first-floor facade. (LCRA Collection, archives of the University City Public Library.)

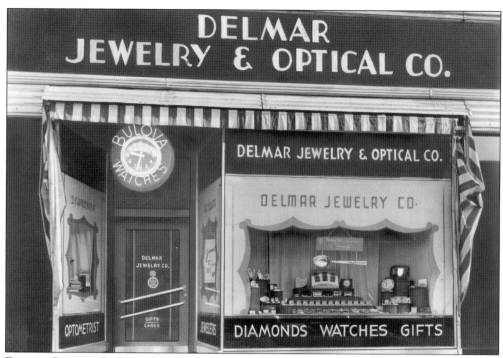

DELMAR JEWELRY & OPTICAL COMPANY, 1948. This store, located at 6519 Delmar Boulevard, offered diamonds, watches, gifts, and sterling flatware, including "Morning Star, Community's newest pattern." An optometrist was available in the store for eye exams. (LCRA Collection, archives of the University City Public Library.)

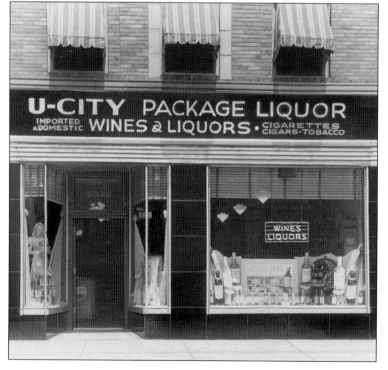

U-CITY PACKAGE LIQUOR, 1948. In addition to a wide selection of imported and domestic wines, beers, and spirits, U-City Package Liquor, at 6525 Delmar Boulevard in the Donaldson Court complex, carried barware, cigarettes, and cigars. After owners Harry and Mary Brandt retired, their son Jay opened the trendy and successful Brandt's Café and Market at the same address. (LCRA Collection, archives of the University City Public Library.)

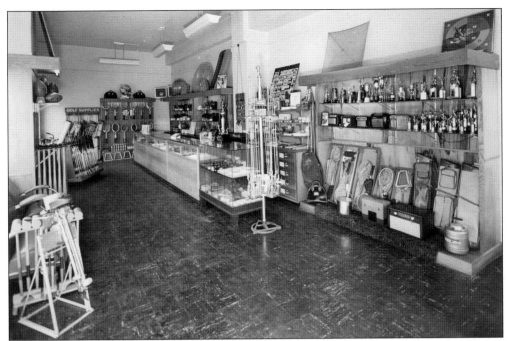

LITTMAN'S SPORTING GOODS STORE, 1948. Located at 6639 Delmar Boulevard, Littman's offered a wide variety of sports equipment. The company was a local distributor of both Wilson and Spaulding equipment and even sold "radios for the armchair athlete." (LCRA Collection, archives of the University City Public Library.)

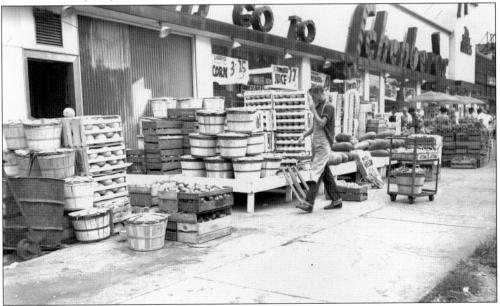

SCHENBERG'S SUPER MARKET, 1950s. Schenberg's, at 6600 Delmar Boulevard, was one of two large grocery stores in the Loop that served not only local residents but also the thousands of streetcar commuters who passed through the Loop each working day. This day, it appears Schenberg's has received a massive, dazzling array of fruits and vegetables. (Archives of the University City Public Library.)

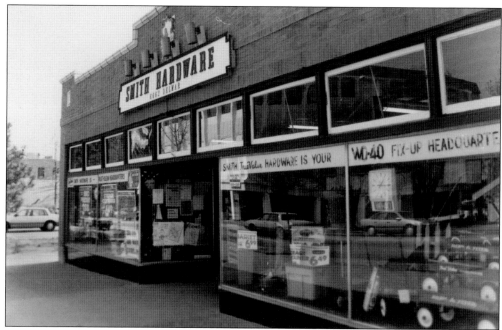

SMITH HARDWARE, 1946. Another Loop stalwart was Smith Hardware, started by Lloyd Smith in 1928 at 6692 Enright Avenue. The store moved to 6661 Delmar in 1930, and finally moved across the street into a much roomier building, at 6662 Delmar, in 1946. Lloyd's son, Richard, joined his father and carried on the business until his own retirement in 2000. (Historical Society of University City.)

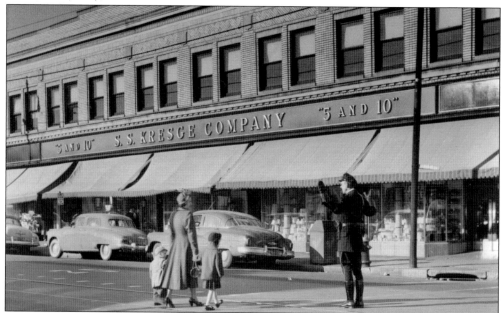

S.S. KRESGE COMPANY "5 AND 10," 1950. The popular variety store at 6655 Delmar Boulevard carried everything from sewing needles to trash cans, from jump ropes to gravy boats. It was the dream store for an afternoon of browsing. Getting a treat at its soda fountain was always a delight. (Archives of the University City Public Library.)

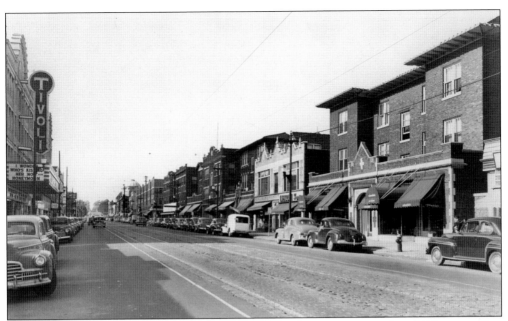

DELMAR, LOOKING WEST, 1948. Most of the street-level stores were retail establishments. One of the best was Rubenstein's Apparel, at 6307 Delmar Boulevard, which proclaimed "Uptown It's Rubenstein's." It also thumped the drum for Young Fashions, its kids' store across the street: "Mothers! . . . No more bothersome trips taking junior, master or miss downtown to shop. Just think! . . . Now you can buy everything they need in our children's store—so close to home." (Archives of the University City Public Library.)

JUST OFF DELMAR, 1948. In addition to the stores on Delmar, there were many busy businesses located on Heman and Enright Avenues on the streetcar loop itself. The Delmar car tracks turned right on Heman to begin the loop to Kingsland and Delmar. Retail locations on this loop were prized because several streetcar lines stopped here, and transfer passengers with time on their hands made good customers. (LCRA Collection, archives of the University City Public Library.)

KLEIN'S ON ENRIGHT, 1945. Carl Klein was the owner/pharmacist of Klein's Pharmacy, located for many years at 6625 Enright Avenue, on the corner of Enright and Heman. Over the years, several different businesses occupied the storefront to the pharmacy's west. Here, the occupant is the Enright Laundry. A large part of Klein's and his neighbors' business came from streetcar passengers waiting to transfer from one line to another. (LCRA Collection, archives of the University City Public Library.)

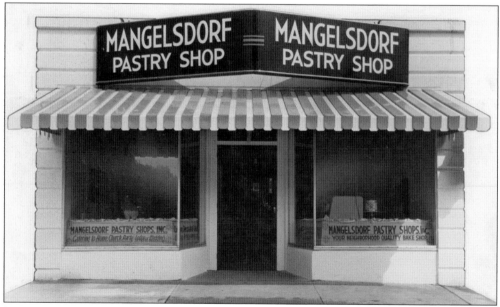

MANGELSDORF PASTRY SHOP, 1948. Modestly billing itself as the "neighborhood quality bake shop," the Mangelsdorf bakery at 606 Heman Avenue faced the streetcar loop. It was a handy stopping-off point for commuters who needed a loaf of bread, rolls for dinner, or fancy cookies for a bridge party. (Archives of the University City Public Library.)

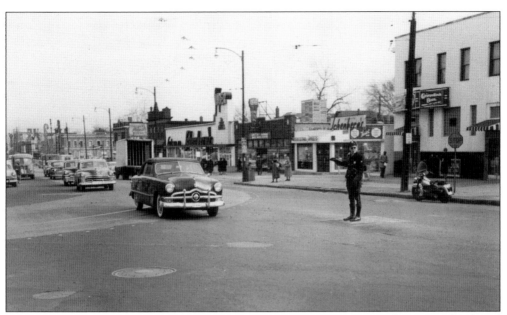

OFFICER DIRECTING DELMAR TRAFFIC, 1948. Until the intersection of Delmar, Kingsland, and Adelaide was reconfigured in the 1970s, traffic patterns were confusing, and police officers were required to direct traffic. Note the officer's motorcycle parked at the curb. (Archives of the University City Public Library.)

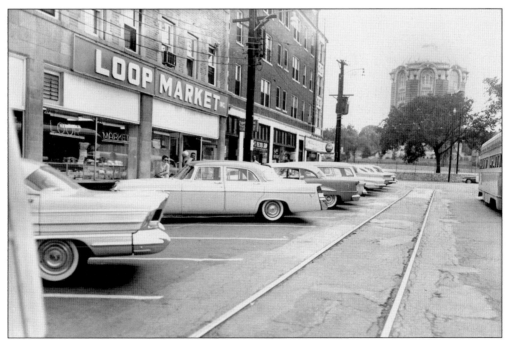

NO PLACE TO PARK. For decades, most Loop shoppers had come on foot or by streetcar or bus. By the late 1940s, however, more and more shoppers were coming by car and were finding parking in the Loop difficult. Here, the few parking spaces on Enright Avenue behind O'Hara's Market are typical of what was available in the Loop. (Archives of the University City Public Library.)

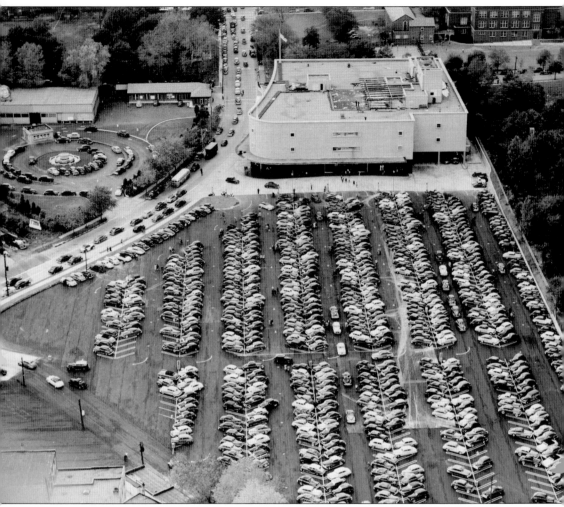

FAMOUS-BARR, CLAYTON, 1948. Famous-Barr, a major downtown department store and headquarters of the nation-wide May Company Department Store, opened its first suburban branch in 1948 on the University City-Clayton border. Ironically, the department's ample parking lot lay inside the University City border but far from the Delmar Loop where Loop merchants were struggling with the issues of inadequate parking for their customers. The circular driveway across the street from Famous-Barr belonged to the Pevely Dairy, an ice cream destination for decades. A beautiful fountain, on whose waters played colored lights, sat at the center of the circle. (Missouri History Museum.)

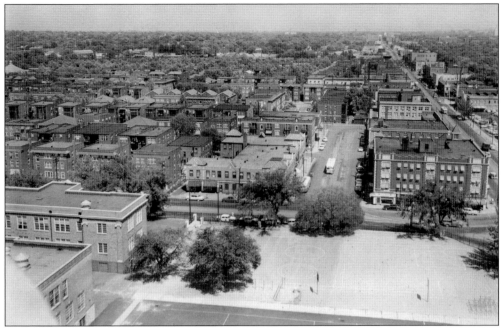

LOOP OVERVIEW, C. 1950. The broad expanse at the bottom of the photograph is the playground used by the Delmar and Harvard elementary schools. At the end of the 1960s, it would be the site of the new University City Public Library. A streetcar is on Enright Avenue, preparing to loop. (Archives of the University City Public Library.)

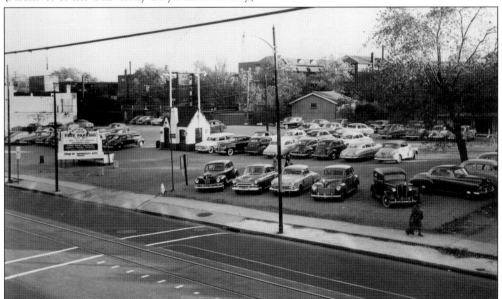

FREE PARKING, 1951. University City was beginning to feel the pressure that other cities and inner-ring suburbs around the country were experiencing: more people had more cars and they needed a handy place to park while they shopped. Or, they could drive out to one of the new malls, where there was plenty of parking. In 1951, the city paved the vacant lot on Delmar where the first city hall had stood and implored drivers to shop in University City. (Archives of the University City Public Library.)

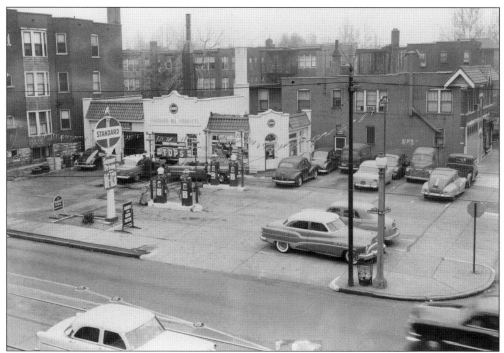

Standard Station, 1955. In the days before divided highways, Delmar and other east-west through streets were heavily used by suburban commuters driving to and from the city, so gas stations did good business in the Loop. This full-service station with three bays was located on the northwest corner of Delmar Boulevard and Eastgate Avenue in the St. Louis City section of the Loop. This luckiest of gas stations backed up on the legendary Pratzel's Bakery. (Archives of the University City Public Library.)

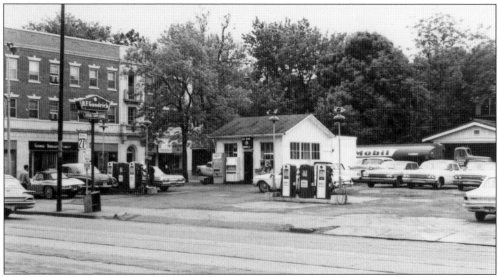

Mobil Station, 1955. This Mobil station was located at the corner of Delmar Boulevard and Limit Avenue. A remodeled version of the station stayed in service well into the 1990s, the last of the old-time stations to survive. An art supply store now stands on that corner. (Archives of the University City Public Library.)

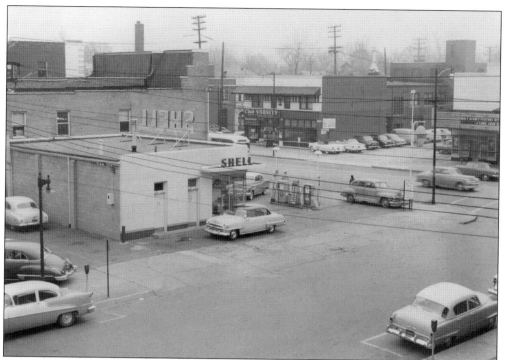

SHELL STATION, 1955. This gas station was located at Delmar Boulevard and Leland Avenue, across Delmar from the Varsity Theatre, the Club Varsity, and offices of the St. Louis County Water Company. The parking lot for Fitz's American Grill and Bottling Works now occupies this site. (Archives of the University City Public Library.)

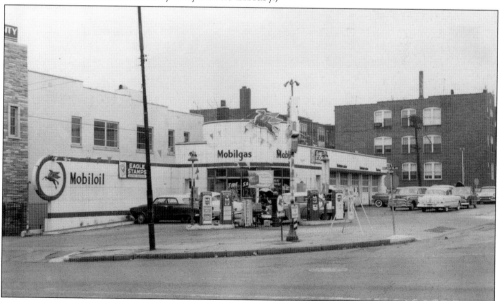

ANOTHER MOBIL STATION, 1955. A Mobil station stood at the busy intersection of Delmar Boulevard and Kingsland Avenue. It was demolished in 1967 to make way for Mutual Federal Savings and Loans's new building. This was a loss not only for nearby car owners but also for collectors of Eagle stamps. (Archives of the University City Public Library.)

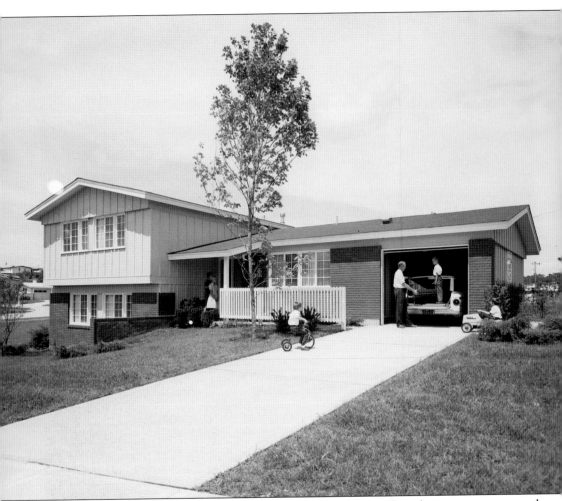

SUBURBIA, 1961. In the housing boom that followed World War II, outlying cow pastures and corn fields gave way to large treeless, gardenless tracts of spanking-new split-level houses, public schools, houses of worship, and shopping malls. The family car had become a vital necessity in this self-contained world. To many new suburbanites, neighborhoods like the Loop represented the past, not the future. (Missouri History Museum.)

Four

GROWING A GREAT STREET

TIVOLI THEATRE SIGN
INSTALLATION, 1995. By the
early 1990s, the condition of the
Tivoli Theatre building, once
a showcase, had so deteriorated
that the building was in
danger of being torn down. Joe
Edwards, who with his wife,
Linda, had opened a modest pub
called Blueberry Hill at 6504
Delmar in 1972, was able to buy
the building and raise funds
for the theater's meticulous
restoration. The apartments
above were turned into office
suites to increase the number
of people coming into the Loop
each weekday. The University
City mayor, Janet Majerus, who
led a parade of city officials
down Delmar to the Tivoli on
opening day, says she looked at
the Tivoli sign and thought, "I
think we're going to make it."
The Tivoli sign was a signal to
all that the Delmar Loop was
alive and on its way back. In
2007, the American Planning
Associate named the Delmar
Loop one of America's "10
Great Streets." (Historical
Society of University City.)

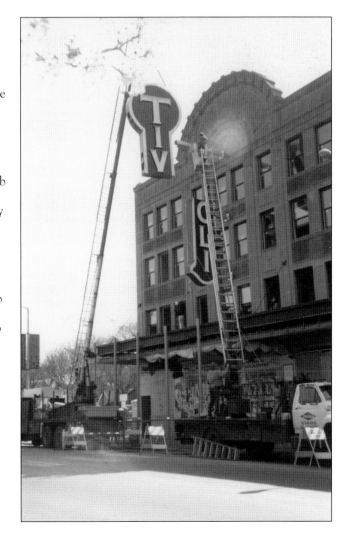

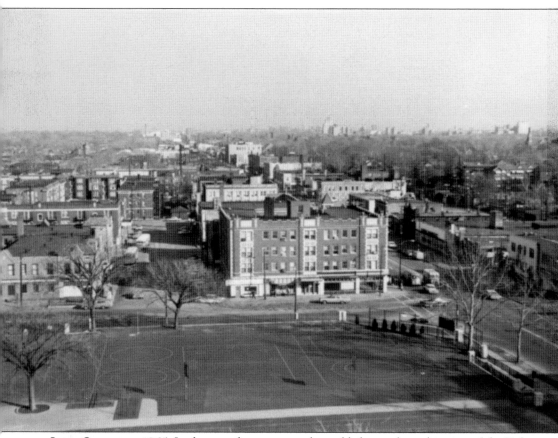

Loop Overview, 1965. In the next few years, much would change from this view of the Delmar Loop. The streetcars had stopped running in the spring of 1964, and the buildings on the north side of Enright's part of the streetcar loop would be demolished. In 1969, the University City Public Library would be built in the open space in the photograph's foreground. Since 1959, the city had been at work charting the future of its endangered inner-ring suburb in a time of enormous change. The first priority was to stabilize the East End, an apartment area full of overcrowded, run-down buildings. The city instituted the occupancy permit: an apartment had to be inspected by the city, and any violations had to be corrected before a new tenant could move in. Unlike many other cities, University City did not bulldoze acres of buildings, preferring instead to repair existing building stock. But some Loop buildings did go under the wrecking ball. (Archives of the University City Public Library.)

CHANGING STOREFRONTS, 1965. By the middle of the decade, many storefronts in the Loop were occupied by service businesses rather than by the retail businesses of earlier years. With redevelopment came change. Here, two service businesses, a laundry–dry cleaner and a printer, are leaving their locations because the building is slated for demolition. In 1948, the fashionable men's shop, The Town Schrier, had occupied 6319E with Shoeland at 6319W. (LCRA Collection, archives of the University City Public Library.)

FISHMAN'S KOSHER DELICATESSEN, 1965. Next door at 6321 Delmar, another building marked for demolition by the Loop redevelopment project, the Fishmans are preparing to move elsewhere in University City. In an era when most retail stores of any kind were closed on Sundays, the message above the store entrance, "Closed Saturday, Open All Day Sunday," was a blessing, soon to be gone, to churchgoers who needed a loaf of bread on a Sunday. (LCRA Collection, archives of the University City Public Library.)

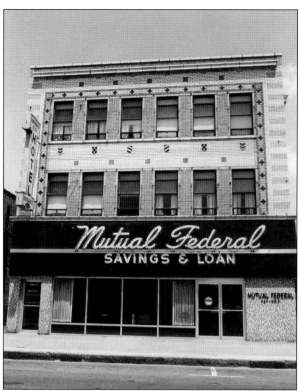

MUTUAL FEDERAL SAVINGS & LOAN, 1965. Another longtime business of Delmar Loop that had several different locations over the years, Mutual Federal Savings & Loan moved into the first floor of the University City Hotel building at 6601–03 Delmar in about 1950. The first floor facade has been modernized, with the hotel entrance now on the left. The building was demolished in 1966 after Mutual Federal moved into its brand new building at 6680 Delmar. (LCRA Collection, archives of the University City Public Library.)

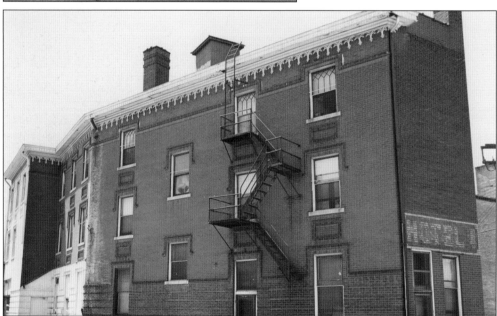

UNIVERSITY CITY HOTEL, 1965. The hotel's street address was 6603 Delmar Boulevard; its peculiar shape came from the fact that it was wedged up against the streetcar tracks of the Kirkwood-Ferguson line, which ran north and south through University City and crossed Delmar about where the present-day statue of Chuck Berry stands. (LCRA Collection, archives of the University City Public Library.)

Mutual Federal's New Building, 1970. Mutual Federal moved into its new building at 6680 Delmar in 1970. This view of the west side of the savings and loan's new home also incorporates the top of one of the towers of O'Hara's Market (now Martin's Fresh Foods). The many-windowed building behind the tower is 6665 Delmar, American National Insurance's three-story building that in the 1960s had been a two-story building. (Archives of the University City Public Library.)

Parking Lot at 6527 Delmar, c. 1966. With Mutual Federal and the University City Hotel gone, the land between the old Delmar Bank Building, now reborn as the World Trade Center, and the House of Liquors, formerly U-City Package Liquor, was ripe for redevelopment. Because the vacant lot had abutted the right-of-way of the long-gone Kirkwood-Ferguson streetcar line, which was now an overgrown eyesore littered with trash, the city decided the best use for all of this land might be a linear park, stretching from the Delmar Loop through an apartment district to Vernon Avenue. It was named in honor of former mayor Harold Ackert. (LCRA Collection, archives of the University City Public Library.)

ACKERT PARK, DELMAR ENTRANCE, 1967. The graceful brick arch opening on to Ackert Park was a welcome addition to the Delmar Loop streetscape. The former Delmar Bank building was now the site of the Lantern House, a Chinese restaurant lauded in *Esquire* magazine for its exquisite banquets. Beyond the Lantern House, at the northwest corner of Delmar Boulevard and Leland Avenue, stands the new University Square Apartments, specifically built with retail stores at street level and office space at its lower level. The city had passed an ordinance requiring that storefronts along the Loop be strictly reserved for retail use only. Existing storefront offices were grandfathered in, but when the tenant moved out, the space reverted to retail. (LCRA Collection, archives of the University City Public Library.)

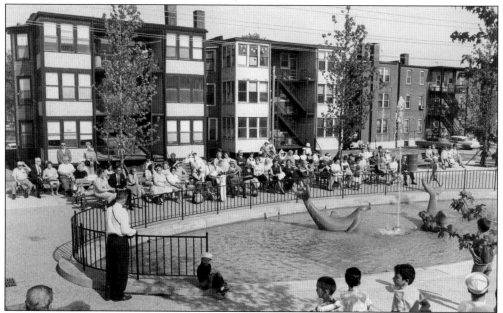

ACKERT PARK DOLPHIN POOL, 1967. The Dolphin Pool and a well-equipped playground provided attractive open space for the many children living in the nearby apartment buildings. (LCRA Collection, archives of the University City Public Library.)

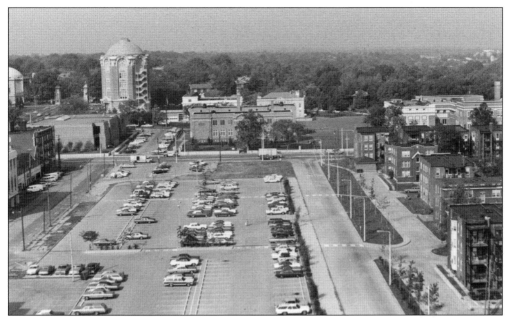

NEW LOOP PARKING, 1975. In 1967, three blocks on the north side of Enright Avenue, once adjacent to the Delmar streetcar loop, were cleared for temporary use as parking lots. They are still in use today, providing critically needed parking for the bustling Delmar Loop. (LCRA Collection, archives of the University City Public Library.)

AMERICAN NATIONAL INSURANCE BUILDING, 1964. In the postwar years, many owners of older commercial buildings sought to make the facades of these buildings look more contemporary. The American National Insurance Building at 6665 Delmar Boulevard underwent one such "modernization." It was nothing to compare with the changes the building would undergo shortly. (LCRA Collection, archives of the University City Public Library.)

DEMOLISHED BUILDING AT DELMAR AND HEMAN, 1966. The wreckage is that of the former S.S. Kresge Company 5&10 at 6649–55 Delmar. The Kresge Company was preparing to make its move into the retail discount market as K-Mart and was not renovating any of its existing stores that it considered too small or too old. Next door at 6665 Delmar, the American National Insurance Building was about to undergo an amazing transformation. (Archives of the University City Public Library.)

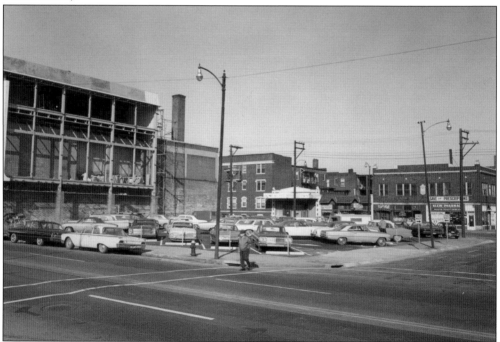

PARKING LOT, DELMAR AT HEMAN, 1968. The Kresge five-and-dime once stood on this lot. On the left, reframing of the American National Insurance Company Building continues. With the Kresge Building gone, Klein's Drug Store and the Enright Laundry on Enright Avenue can be seen from Delmar Boulevard. (Archives of the University City Public Library.)

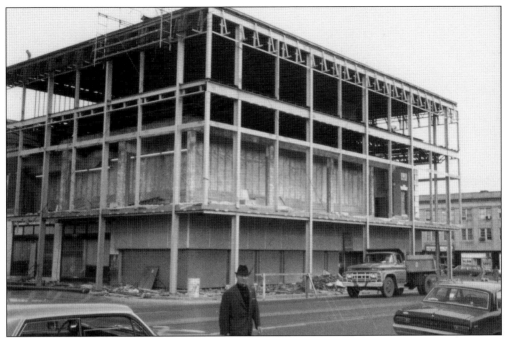

AMERICAN NATIONAL INSURANCE COMPANY BUILDING, 1967. The radical reconfiguration of this building was part of the Delmar Loop redevelopment program. Here, a third story is being added to the former two-story 1920s brick building, and new exterior walls are being constructed. (LCRA Collection, archives of the University City Public Library.)

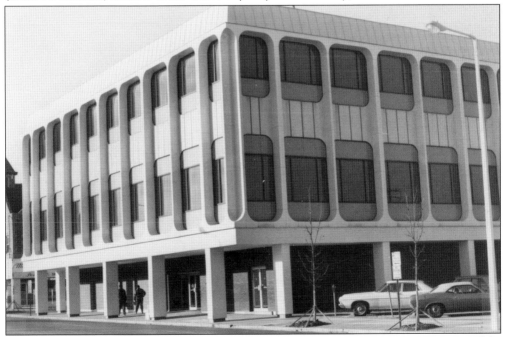

AMERICAN NATIONAL INSURANCE COMPANY BUILDING, JANUARY 1970. The transformation of the building, with an added third story, is complete. (LCRA Collection, archives of the University City Public Library.)

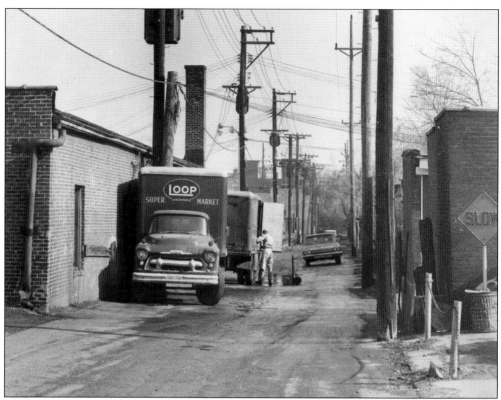

LOOP ALLEY, 1963. Not all Loop redevelopment plans involved demolition. For example, the alley behind the buildings on the south side of the 6600 block of Delmar Boulevard, heavily used but poorly laid out, needed attention. (Archives of the University City Public Library.)

FORMER LOOP ALLEY, 1970. Renamed Avenue A, the alley (now Loop South) was redesigned and rebuilt to facilitate access to the new parking lots of Commerce Bank and other Loop businesses, seen at right. (LCRA Collection, archives of the University City Public Library.)

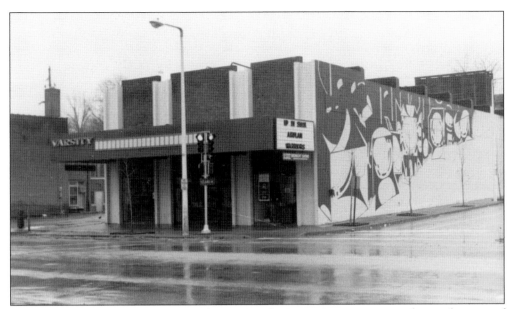

VARSITY THEATRE, 1970. During the late 1960s, the Varsity's exterior was redesigned as part of the Delmar Loop redevelopment project. A new street had been created when the building next to the Varsity was removed, so a mural was added to this formerly hidden brick wall. (Historical Society of University City.)

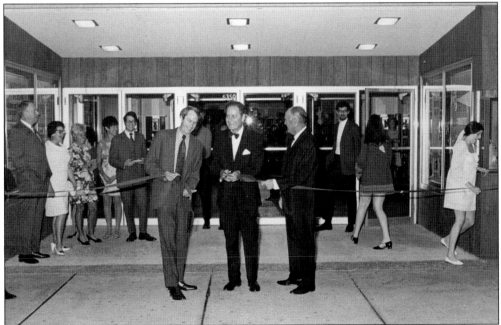

MAGIC LANTERN, 1969. In 1969, the facade of the Tivoli Theatre, at 6350 Delmar Boulevard, was remodeled and the theater was reopened as the Magic Lantern Cinema by Arthur Enterprises, Inc., and the St. Louis Cinema Arts Educators. The goal was to offer the best in classic and contemporary film art. Shown here cutting the ribbon in October 1969 are Edward Arthur (left), representing Arthur Enterprises, Mayor Nathan Kaufman (center), and James Scott of Cinema Art Educators. It closed in the mid-1970s. (LCRA Collection, archives of the University City Public Library.)

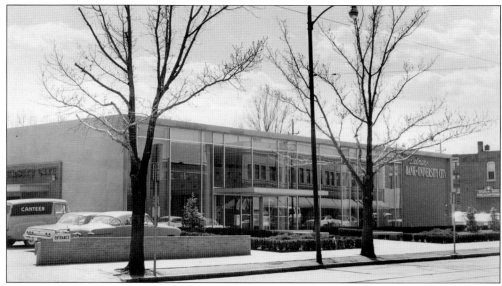

DELMAR BANK OF UNIVERSITY CITY, 1965. Another institution that has made its home in the Loop for decades was the Delmar Bank, which has been part of the Commerce Bank family since 1969. Founded in 1913 as the West End Bank with offices at 6500 Delmar, in 1928, it moved to 6505 Delmar. During the Bank Holiday of 1933, it was reorganized as the Delmar Bank. In 1959, the bank moved into its new quarters at 6630 Delmar. In the 1980s, the bank building was reconfigured to include a separate retail shop and a restaurant. (LCRA Collection, archives of the University City Public Library.)

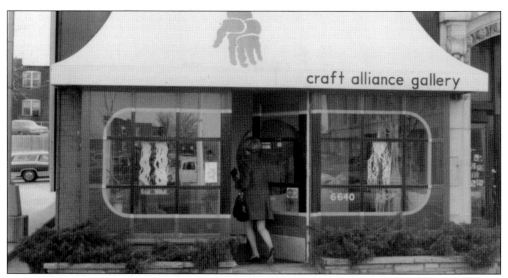

CRAFT ALLIANCE, 1970. The oldest building in the Loop had, by 1970, become one of the most attractive. The site, housing the Craft Alliance Gallery, not only was a welcome burst of creativity in the Loop, but its exhibitions and classes promoting contemporary arts also drew visitors and customers from all over the region. (LCRA Collection, archives of the University City Public Library.)

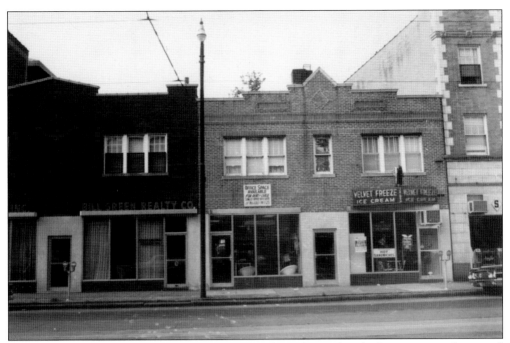

VELVET FREEZE, 1965. Though many longtime merchants knew that the Loop was on a downward slide, they remained until it was no longer feasible. Among the holdout businesses was Velvet Freeze, at 6380 Delmar. These two storefronts east of the ice cream store are offices, not retail. (LCRA Collection, archives of the University City Public Library.)

BATON MUSIC, 1965. Baton Music, shown here at its 6394 Delmar Boulevard location, had several different addresses during its long tenure in the Loop, not uncommon among shop owners of the day. (LCRA Collection, archives of the University City Public Library.)

MARYLAND CAFÉ, 1965. Located at 6510 Delmar Boulevard in the western end of the old Smith Block, the Maryland Café, famous for its tasty and affordable blue-plate specials, never lacked for customers. (LCRA Collection, archives of the University City Public Library.)

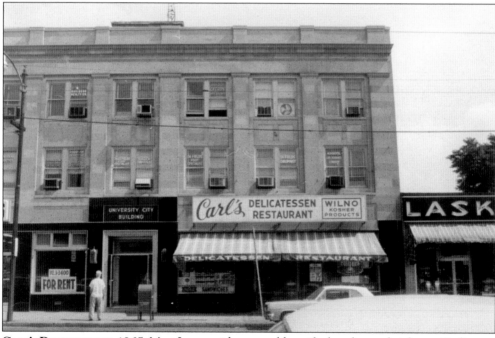

CARL'S DELICATESSEN, 1965. Most Loop residents would testify that the sandwiches at Carl's were out of this world. This delicatessen was at 6633 Delmar Boulevard in the former Bank of University City Building. (LCRA Collection, archives of the University City Public Library.)

THE COFFEE POT, 1965. The Coffee Pot was located at 6200 Delmar Boulevard, so technically it was not part of the University City Loop, but no one seemed to hold it against the establishment. (LCRA Collection, archives of the University City Public Library.)

WITHINGTON TYPEWRITER & SUPPLY COMPANY, 1965. By virtue of its 6302 Delmar Boulevard address, this busy store was in the City of St. Louis, but it drew many University City customers to its doors. Later, it moved west to 6312–6314 Delmar. (LCRA Collection, archives of the University City Public Library.)

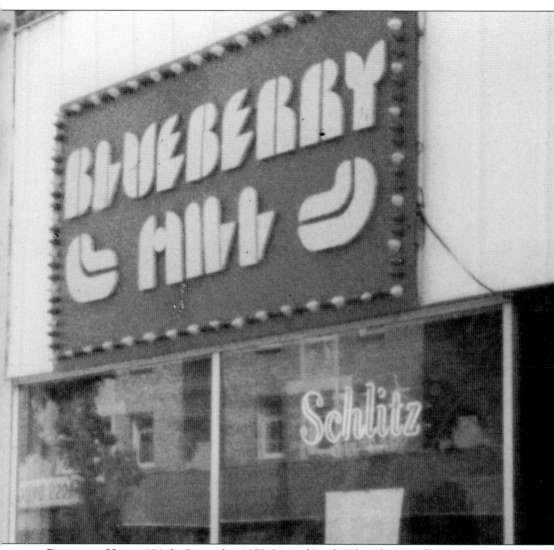

BLUEBERRY HILL, 1972. In September 1972, Joe and Linda Edwards, using $10,500 borrowed from friends, opened what they hoped would become a friendly neighborhood pub. They chose the storefront at 6504 Delmar Boulevard because the rent was cheap and Joe was looking for a place in which to display his many collections of pop culture memorabilia. They first had to overcome a pair of unfriendly motorcycle gangs and a city council that was concerned about issuing a liquor license to an establishment in the still dubious Delmar Loop. But the city had accomplished much over the preceding decade, and a group of new and longtime Loop business owners began to build upon that foundation. (Archives of the University City Public Library.)

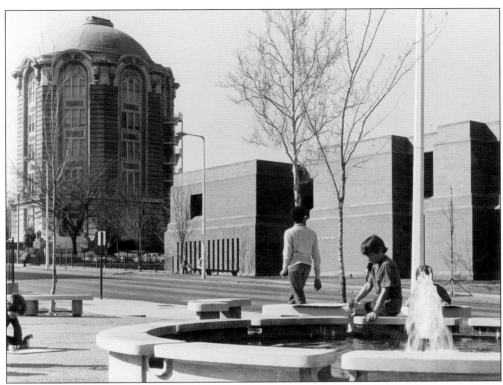

EPSTEIN PLAZA, 1974. In 1964, when the mind-boggling Delmar-Kingsland-Adelaide intersection was reconfigured, a small park was created across Delmar from the soon-to-be built (right) University City Public Library. In 1974, the park was redesigned, a fountain, benches, and landscaping were added, and it was dedicated to Zelda and Milton Epstein, longtime University City residents and civic leaders. (Archives of the University City Public Library.)

THE RAIN MAN SCULPTURE, 1996. "The Rain Man" began a temporary stay in the Epstein Plaza fountain in 1994 as part of the Annual University City Sculpture Series. Constructed of plywood by Washington University student Gregory Cullen, the man with the umbrella won the hearts of passersby. The University City Arts and Letters Commission raised the funds to have him cast in bronze in 1996, then reinstalled him in the plaza's fountain, where he continues his walk in the rain. (Archives of the University City Public Library.)

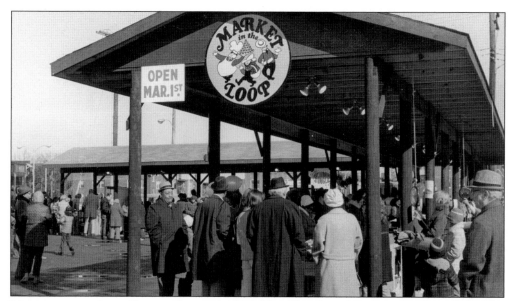

MARKET IN THE LOOP GRAND OPENING, 1975. The Chamber of Commerce initiated the idea of a farmer's market in the Delmar Loop. The combined efforts of the city's Land Clearance for Redevelopment Authority, the City Council, Commerce Bank and the Missouri National Guard transformed the idea into reality. The Market in the Loop opened on March 1, 1975 with more than two dozen applications for the 15 stalls then available. (Archives of the University City Public Library.)

CUTTING THE RIBBON, 1975. The "ribbon" cut by officials and friends to open the Market in the Loop consisted of fruits and vegetables. Present in the first row (left to right) are city manager Charles T. Henry, city council member Elsie Glickert, State Representative Kenneth Rothman, city council member Hadley Grimm, and Deana Jarboe, Miss Teenage University City. Seated in front is Martin Mantia, newly appointed Market in the Loop manager. (Archives of the University City Public Library.)

BLUEBERRY HILL'S 10TH ANNIVERSARY, 1982. The Loop was looking up. Blueberry Hill not only had survived a decade but expanded through several storefronts in its building. Up the street, Paul's Books, owned and operated by Paul and Suzanne Schoomer, also was celebrating 10 years. Loop merchants had formed a special business taxing district to improve the appearance and safety of a rather grim-looking Loop: dusk-to-dawn street and alley lighting, flower-filled planters, colorful awnings, swept sidewalks and gutters, and improved security. Owner-operated specialty shops, restaurants, and music clubs began to make the Delmar Loop a destination once again. (Archives of the University City Public Library.)

THE VARSITY CLOSES, 1982. Today the Varsity building is the 7,000 square foot home of the fabled Vintage Vinyl, a Loop standout for more than three decades. After the Varsity closed, it was gutted and remodeled to house a unit of a drugstore chain that ultimately failed. Although now there are some chain restaurants on Delmar, the Loop continues to encourage businesses that are owner-operated. (Historical Society of University City.)

St. Louis Walk of Fame, 1988. The brainchild of Blueberry Hill's Joe Edwards, the nonprofit Walk of Fame honors "individuals connected with the St. Louis area who made major national contributions to our culture." Imbedded in the sidewalk along the length of the Delmar Loop is a brass star for each honoree, accompanied by a brass plaque that contains a brief biography of the individual. T.S. Eliot, Ozzie Smith, Betty Grable, Bill Mauldin, and Ulysses S. Grant are among the dozens of honorees. (Archives of the University City Public Library.)

Chuck Berry, 1988. The first person inducted into the Rock and Roll Hall of Fame, Chuck Berry also was the first person inducted into the St. Louis Walk of Fame. Once a month, Berry performs in Blueberry Hill's Duck Room alongside his son and granddaughter. In 2011, an eight-foot statue of Berry as a young man was unveiled in the Loop, across Delmar Boulevard from Blueberry Hill. (Hope Edwards.)

THE ROCKETTES, 2007. The Radio City Rockettes, the world's most famous precision dance team, has St. Louis roots. Two Rockettes, both native St. Louisans, attended the dance troupe's induction into the St. Louis Walk of Fame. Pictured are (from left to right) Walk of Fame founder Joe Edwards, Karilyn Ashley Surratt, Lara Turek, and University City mayor Joe Adams. (Joe Edwards.)

THE MISSOURI ROCKETS, 1930. In 1925, impresario Russell Markert of St. Louis billed a group of outstanding women dancers as the Missouri Rockets. They went on to take New York by storm when they danced on the opening night of New York City's Radio City Music Hall on December 27, 1932. (Missouri History Museum.)

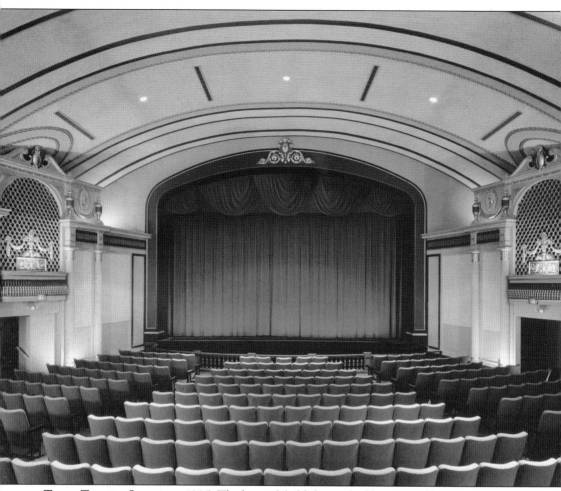

Tivoli Theatre Interior, 1995. The beautiful old theater had become a destination for visitors as well as for locals, as much for its character as for its often intriguing bills of fare. For Joe Edwards, though, something else very intriguing had arisen in the east. In 1993, the MetroLink, St. Louis's brand-new light rail system, had opened its Delmar Loop Station just three blocks east of Blueberry Hill. But they were three of the longest, bleakest blocks one could imagine. So, like E.G. Lewis before him, Edwards devised a plan to bridge that gap. The plan involved large buildings and crowds of people, but was without Lewis's sketchy brand of financing. (Hope Edwards.)

Five

IF YOU BUILD IT,
THEY WILL COME

THE PAGEANT, 2000. On October 19, 2000, the Pageant, Joe Edwards's and Pat Hagin's $7-million concert venue at 6161 Delmar Boulevard, opened with a sold-out Chuck Berry concert. Anchoring the once dank stretch of Delmar, about halfway between the Delmar Metro light-rail station and the lively Loop west of Skinker Boulevard, the Pageant is regarded as St. Louis's premier midsize music venue, designed from the ground up with customers and performers in mind. It is the place where touring national acts in pop, indie rock, hip-hop, jazz, blues, and stand-up comedy play before they hit the arena circuit. In 2012, trade publication *Pollstar*, which covers the worldwide concert industry, ranked the Pageant No. 4 among the top 50 club venues—worldwide—based on the number of tickets sold in a calendar year. Each year, thousands upon thousands of people visit it and the shops and restaurants that have grown up around it. (Hope Edwards.)

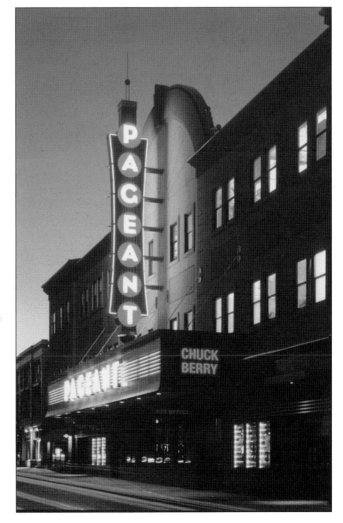

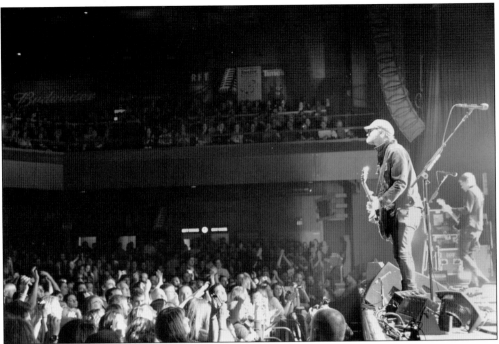

AUDIENCE AT THE PAGEANT. Groups of 20 or more can reserve seats in the balcony at the Pageant, but standing room looks like a lot more fun. (Hope Edwards.)

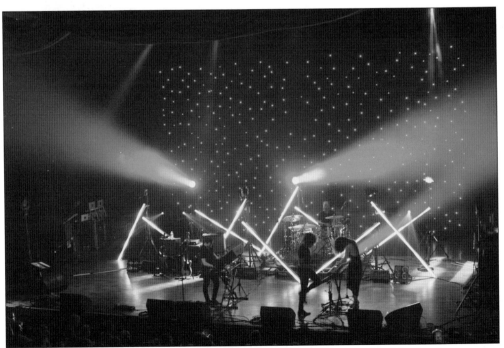

PAGEANT LIGHT SHOW. The Pageant is equipped with state-of-the-art sound and (as the photographer attests) state-of-the-art lighting. (Hope Edwards.)

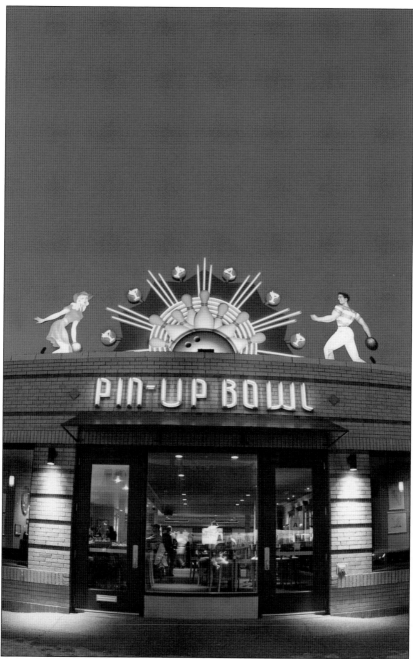

Pin-Up Bowl, 2003. Billing itself as "The Original Bowling and Martini Lounge," the Pin-Up Bowl, located at 6191 Delmar Boulevard, has many devoted fans, among them St. Louis–born rapper Nelly, who bowls a fine, fine game. A columnist for the trade magazine *Draft* praised the Pin-Up's bar, adding, "This St. Louis bowling institution boasts about its creative cocktails, but the real treat is the small but wonderful beer menu that pairs disturbingly well with the cherry and blueberry Pop Tarts on offer." The building had most recently housed a retail carpet store. When the premises were renovated and substantially enlarged by Joe Edwards, he retained the building's middle-aged but familiar facade. (Mark S. Gilliland.)

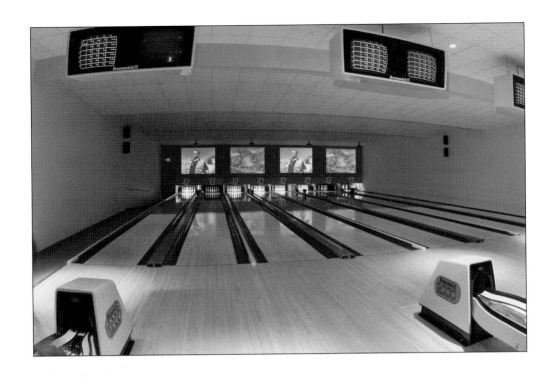

PIN-UP BOWL ALLEYS AND BAR. Pin-Up customers can enjoy a beer or martini at the bar (below) and an exciting game of bowling (above). (Both, Mark S. Gilliland.)

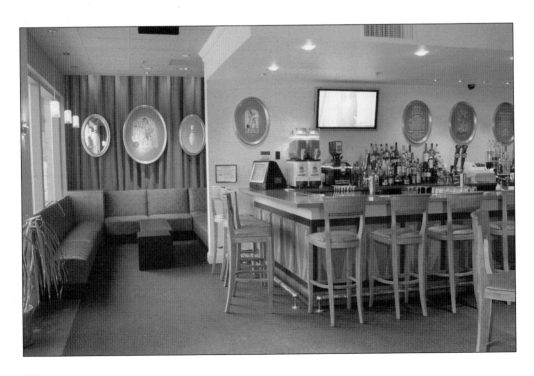

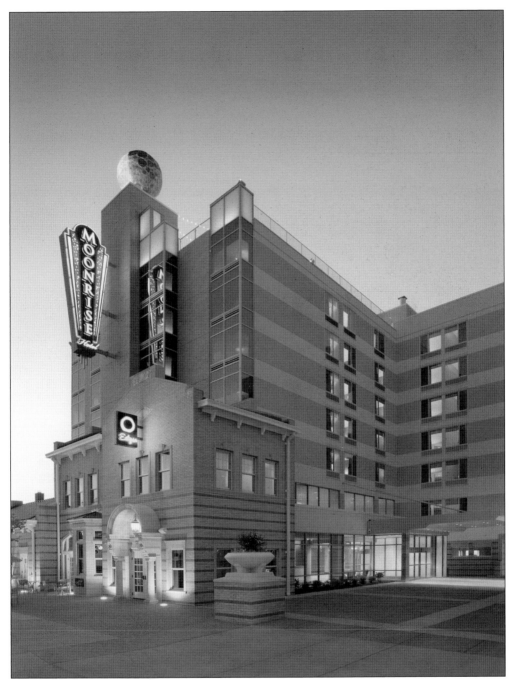

MOONRISE HOTEL, 2009. In April 2009, Joe Edwards opened the doors of the Moonrise Hotel at 6177 Delmar, a project he had long envisioned for the reviving section of the Delmar Loop east of Skinker. A luxury boutique hotel, the Moonrise is seven stories tall, with Rooftop Terrace bars that feature the world's largest man-made rotating moon. In 2011, the American Automobile Association awarded the Moonrise Hotel its Four Diamond designation. To win the award, a hotel must be "refined, stylish with upscale physical attributes, extensive amenities and a high degree of hospitality, service and attention to detail." (Debbe Franke.)

Moonrise Hotel's Eclipse Restaurant. Just off the lobby, the Eclipse Restaurant offers fine dining using local, seasonal and organic ingredients. Menu selections change quarterly on every equinox and solstice. The exterior wall of the original building on the hotel's site is incorporated in the exterior wall of the Eclipse. (Debbe Franke.)

Moonrise Hotel's Agnes Moorehead Suite. The Walk of Fame that Joe Edwards started in the Loop in 1988 to honor St. Louis notables appears to have followed him right into the Moonrise Hotel. Edwards opened the boutique hotel at 6177 Delmar Boulevard in April 2009. Edwards also had an important role in persuading the Regional Arts Commission of St. Louis to build a striking new headquarters building at 6128 Delmar, which opened in 2003, across the street from the Pageant. (Debbe Franke.)

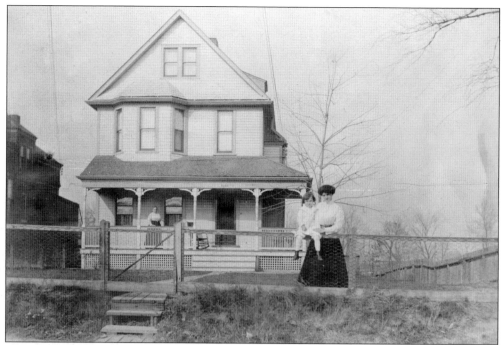

SITE OF MOONRISE HOTEL, 1900. The Joseph A. Muldoon residence (above) at 6165 Delmar was built in 1895. It stood just about where the Moonrise is located now. The Muldoon women seem proud to pose in front of their spacious home, conveniently located next to a trolley line. (Missouri History Museum.)

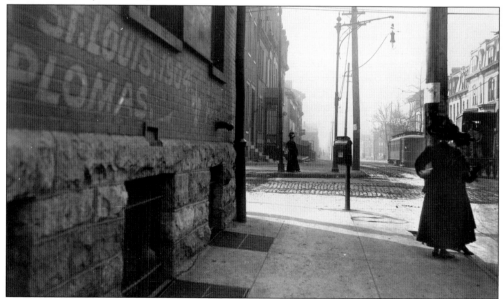

STREETCAR STOPS, 1900s. The electric streetcar spelled intoxicating freedom for city dwellers. It was speedy, inexpensive and its routes covered both St. Louis City and the county beyond. Though streetcars vanished from most American streets by 1970, in recent years they have become a topic of serious interest in cities across the United States. The Delmar Loop is no exception. (Missouri History Museum.)

LOOP TROLLEY, 2014. A fleet of fixed-rail electric streetcars is set to travel from the west end of the Delmar Loop, east 2.2 miles to the Missouri History Museum at the northern edge of Forest Park. It will pass two heavily used Metro stations on its journey. In addition, Joe Edwards, who has worked on the idea of a Loop trolley since 1997, sees it not only as handy means of transportation for tourists and locals but also as an engine of change for neighborhoods east of the Loop. In the following pages, the Loop Trolley travels through times past. (Missouri History Museum.)

SKINKER AND DELMAR, 1902. Shown here is southbound Skinker Boulevard as seen from Delmar Boulevard. The beautiful Parkview subdivision was just beginning to rise from the pastureland on the right, and it would be a long while before the roads were paved. But the trolley was running right along Delmar. Today, 20,00 vehicles cross this intersection each day. (Missouri History Museum.)

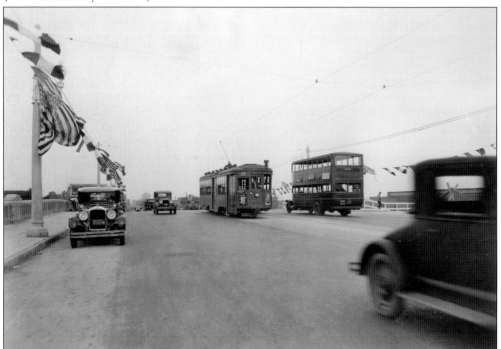

DELMAR BRIDGE, 1925. Streetcar, bus, and automobile traffic rushes east and west on this bridge spanning the Wabash Railroad tracks. These days Metro, St. Louis's popular light rail system, uses the Wabash tracks. The eastern section of the Delmar Loop, beyond the Wabash Bridge, is experiencing new construction and the arrival of interesting restaurants and shops. (Missouri History Museum.)

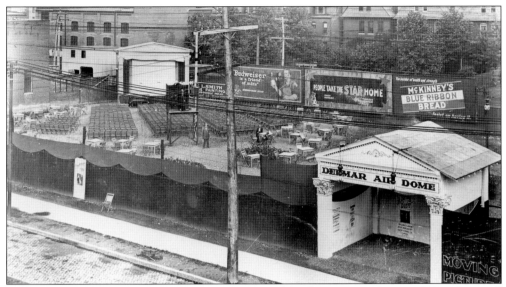

AIR DOME, 1900. While an open-air walk-in movie like this one at Delmar and Hamilton will probably never be revived, an outdoor movie in an era without air-conditioning held the promise of cold beer and light comedy for sweltering St. Louisans. (Missouri History Museum.)

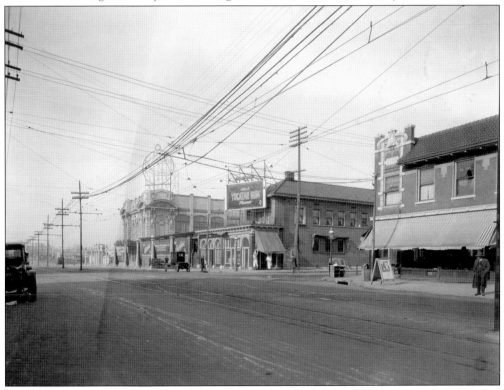

LOOP INTERSECTION, 1919. Here is the intersection of Delmar and Hamilton again, this time looking a little worse for wear. The Pershing Theatre (left of center), opened in 1914, and was located one block west of the Pageant Theatre, namesake of Joe Edward's Pageant. (Missouri History Museum.)

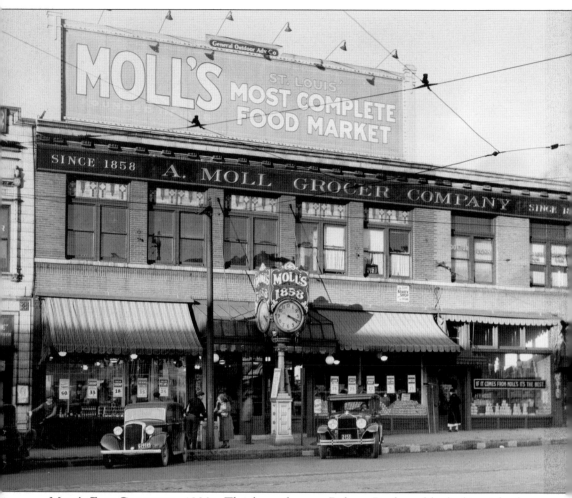

MOLL'S FINE GROCERIES, 1920S. This large shop on Delmar Boulevard looked straight down DeBaliviere Avenue, and here is where the Loop Trolley will make its turn south down DeBaliviere as it heads for the Missouri History Museum in Forest Park. The handsome clock on Moll's sidewalk was saved when the building was demolished in the 1950s. It now graces a small park on Laclede's Landing in downtown St. Louis. (Missouri History Museum.)

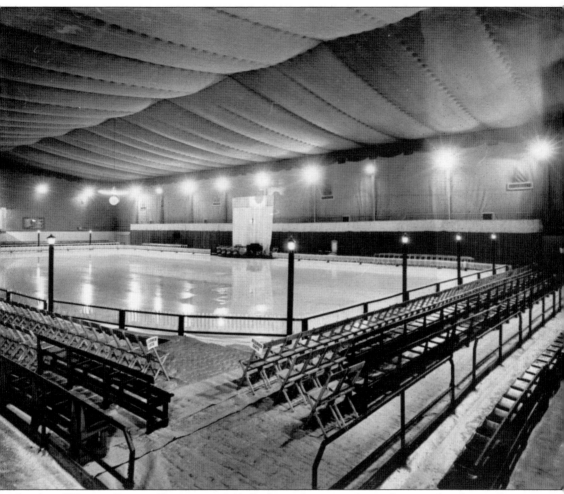

Jai Alai/Winter Garden Building, 1914. Built as a fronton to be used in matches during the 1904 World's Fair, this space was later converted into a rink for speed skaters. The building, at the corner of DeBaliviere and Kingsbury Avenues, was demolished in the 1960s. Its name lives on today, attached to a senior citizens' apartment building. (Missouri History Museum.)

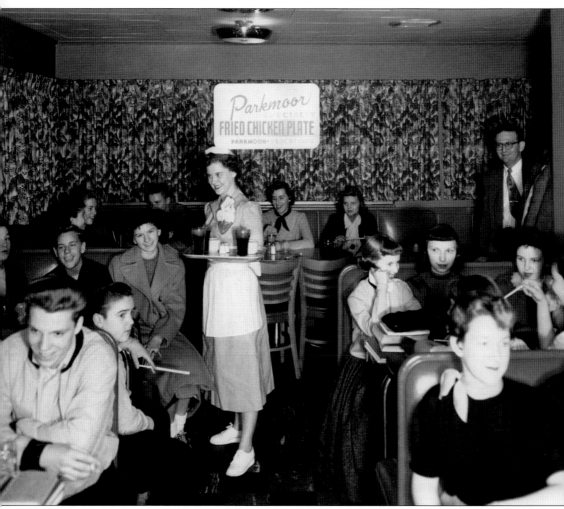

THE PARKMOOR, 1959. One of six Parkmoor restaurants in the St. Louis area, this one was located at 324 DeBaliviere Avenue, in the heart of a shopping district frequented by the thousands of patrons who lived in the many nearby apartment houses. The Parkmoor offered not only its fried chicken plate, but also its Pedigree Sandwich, a hot dog smothered in cheese and bacon. The gentleman standing (right) at the back of the restaurant is the manager, Freddy Springs. (Missouri History Museum.)

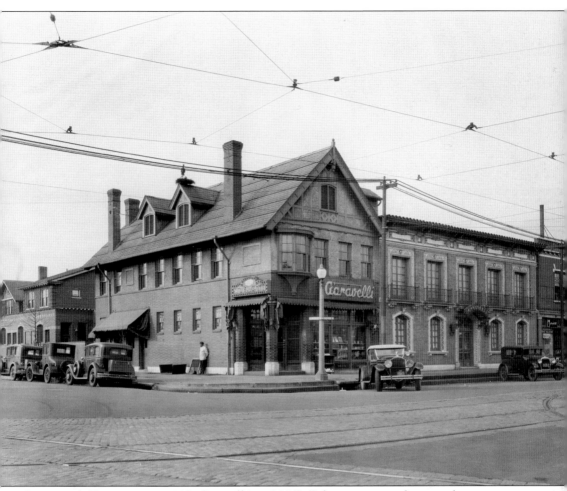

GARAVELLI'S RESTAURANT, 1932. Garavelli's at 300 DeBaliviere was a cafeteria-style restaurant but one with a marble fountain, crystal chandeliers, and a steamship round of beef carved as the diner wished. For many years it was an anchor of the DeBaliviere shopping district, even in the 1960s when the area had become the DeBaliviere Strip, a collection of seedy clubs and theaters. The Strip's most famous attraction was stripper Evelyn "$50,000 Treasure Chest" West whose bosom, it was reported, was insured by Lloyd's of London. Garavelli's was torn down in 1987, but developer Leon Strauss and his associates at his Pantheon Corporation had already begun to rehabilitate the hundreds of abandoned and battered apartment houses east of DeBaliviere. A ride down DeBaliviere on the Loop Trolley offers a look at the past as well as at the future. (Missouri History Museum.)

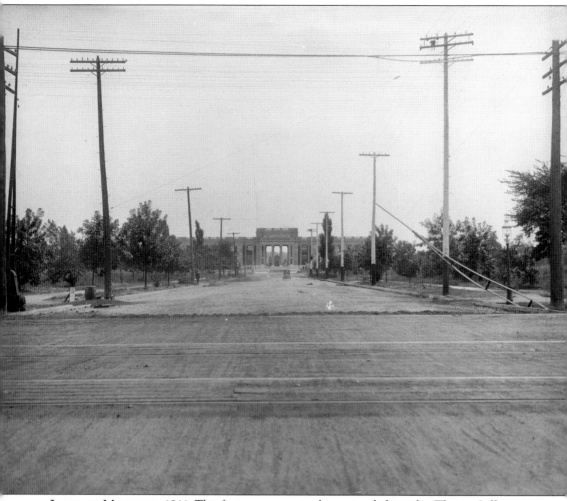

JEFFERSON MEMORIAL, 1911. This first monument in the nation dedicated to Thomas Jefferson was paid for with Louisiana Purchase Exposition funds and honors his role in the Louisiana Purchase. It was dedicated in 1913 and contains a statue of Jefferson by Karl Bittner. The building in Forest Park is the home of the Missouri History Museum. (Missouri History Museum.)

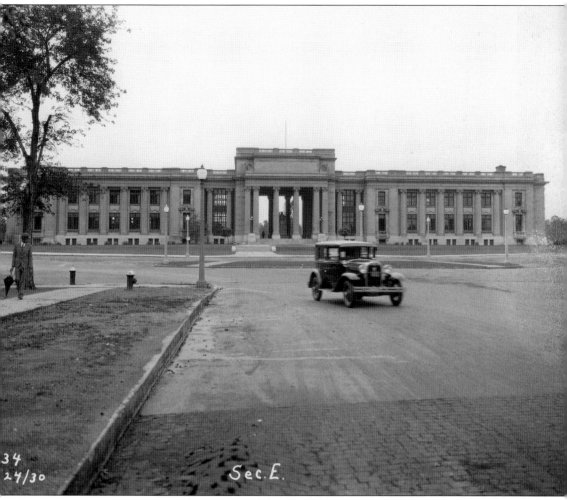

Jefferson Memorial, 1930s. This Forest Park location is where the Loop Trolley turns around and heads back to the Delmar Loop. Today, 12 million people visit Forest Park each year; now they can park the family sedan and take the trolley to the bustling Delmar Loop. (Missouri History Museum.)

BIBLIOGRAPHY

Brodkey, Harold. *First Love and Other Sorrows.* Holt Paperbacks, 1998.

Costantin, M.M. *Sidestreets St. Louis.* Sidestreets Press, 1981.

Delmar Loop Photograph Collection. www.ucpl.lib.mo.us

E.G. Lewis Photograph Collection. www.ucpl.lib.mo.us

Gass, Mary Henderson et al. *Parkview: a St. Louis Urban Oasis 1905–2005.* Virginia Publishing Company, 2005.

Hamilton, Esley. *The University City Civic Plaza: A Brief History of its Planning and Architecture* Historical Society of University City, 1981.

Harris, NiNi. *Legacy of Lions.* Historical Society of University City, 1981.

Henry, Charles T. *A History of Community Sustainability and Beginning the Eliminating of Racial Redlining in the Metro Area 1959–1975: University City a Middle-class Inner-ring Suburb of St. Louis.* Historical Society of University City, 2012.

Little, Judy et al. *University City: Landmarks and Historical Places.* City of University City, 1997.

Longo, Jim. *A University City Album: Remembrances and Reflections of Seventy-five Years.* Citizens Committee for the Seventy-fifth Anniversary. c. 1981.

Martin, S.W. *Atascadero.* Arcadia Publishing, 2011.

McDonald, Susan Waugh. *Edward Garner Lewis: Entrepreneur, Publisher, American of the Gilded Age.* Bulletin of the Missouri Historical Society, (April 1979) Volume XXXV, No. 3 pp. 154–163.

Mendelson, Robert E. et al. *Community Harmony; The Reuse of Ordinary Structures.* Center for Urban and Environmental Research and Services. Southern Illinois University at Edwardsville, January 1980.

Murray, C. Edwin and Ilene Kanfer Murray. *University City, Missouri: Its People and Events, 1906–1931.* Historical Society of University City, 2009.

Primm, James Neal. *Lion of the Valley: St. Louis, Missouri.* Pruett Publishing Company, 1981.

University City Council meeting minutes. April 18, 1912–present. www.ucitymo.org

Savage, Charles. *Architecture of the Private Streets of St. Louis.* University of Missouri Press, 1987.

Wright, John A. *University City, Missouri.* Arcadia Publishing, 2002.

AFTERWORD

Edward Gardner Lewis
1869–1950
Banker, Planner, Developer, Builder, Publisher,
Inventor, Artist, Dreamer, Visionary
Founder of University City
Incorporated September 4, 1906
First Mayor of University City (1906–1913)
He left us with a remarkable legacy.

—Text from a marker dedicated September 3, 2006
in celebration of University City's centennial

"I guess I'm an eternal optimist, because I think we'll see a thriving riverfront (on both sides of the Mississippi), a strong central corridor, flourishing neighborhoods and parks connected by trolley 'spurs' to a mass transit system envied by other cities. The city and county will merge and, after much debate, a regional growth plan will be endorsed by all surrounding counties. Much of this will be possible due to the blossoming of the bio-tech field, which will spawn new Fortune 500 companies and high-paying jobs, which in turn will generate more support for cultural organizations and activities. St. Louis will be voted No. 1 in 2025."

—Joe Edwards
St. Louis Business Journal
January 30, 2000

"The business establishment has been willing to listen to [Edwards] because he's been so successful. He's an unusual combination—hippie-visionary-business type."

—Bill McClellan
St. Louis Post-Dispatch columnist,
quoted in the *Christian Science Monitor*
"People Making a Difference" daily feature
December 14, 2012

DISCOVER THOUSANDS OF LOCAL HISTORY BOOKS FEATURING MILLIONS OF VINTAGE IMAGES

Arcadia Publishing, the leading local history publisher in the United States, is committed to making history accessible and meaningful through publishing books that celebrate and preserve the heritage of America's people and places.

Find more books like this at
www.arcadiapublishing.com

Search for your hometown history, your old stomping grounds, and even your favorite sports team.